Enchanting
NEW ZEALAND

LIZ LIGHT

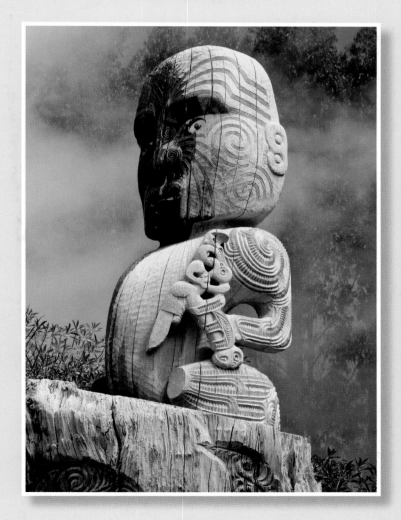

JOHN BEAUFOY PUBLISHING

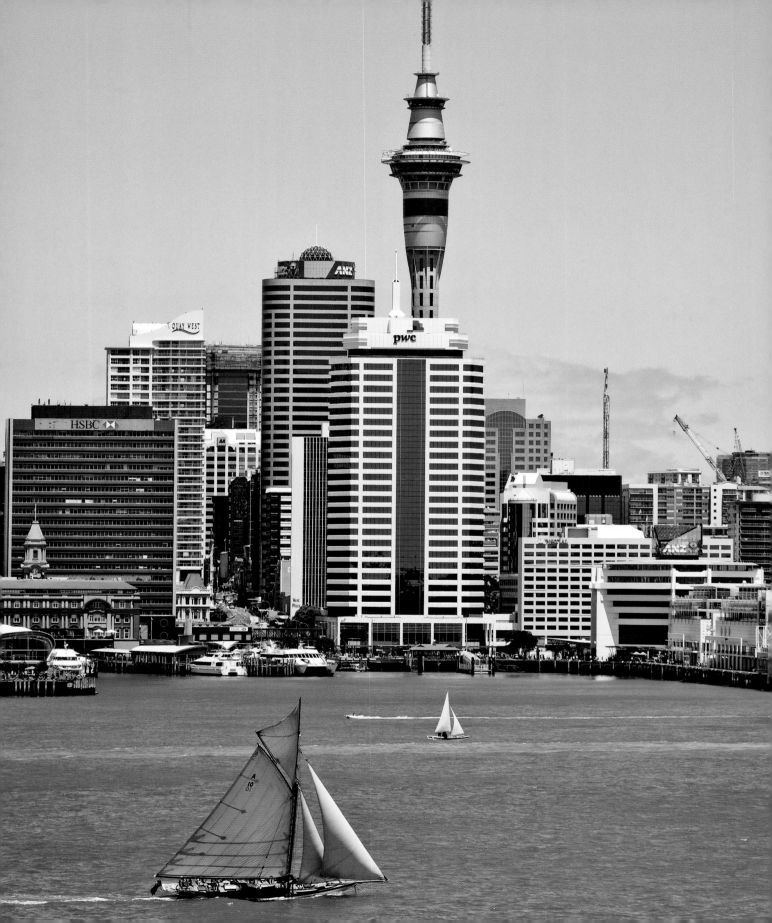

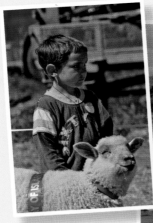

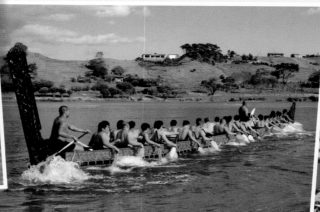

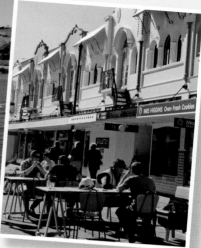

Contents

Above right: New Regent Street, a 1930's Spanish Mission-style, pedestrian precinct in Christchurch.

Above left: A prize-winning pet lamb at the Bay of Islands Pastoral Show, Northland.

Above centre: Waka practice on Taipa Estuary, Northland.

Opposite: Summer in downtown Auckland.

Title page: Ngātoroirangi, stands guard at Wairākei Terraces hot pools and park, Taupō.

Chapter 1: Splendid Isolation

New Zealand is a remote jewel in the southern Pacific Ocean; it is as far from Europe as it is possible to get. The nearest country, Australia, lies beyond 2,200 km (1,370 miles) of blue sea.

This isolation has shaped the land, culture and personality of the nation. It cannot claim to be a wealthy country, the distance between it and trading partners is too great for that, and there are few natural resources of the kind that one can mine. It has minimal oil reserves and no heavy industry.

But, geographically, it is a microcosm of all that is wondrous and beautiful in the rest of the world, in an accessible package. Visitors come to New Zealand to see the true colour of blue where clear sky joins the ocean on a far horizon. And they see green as pasture-covered hills fold gently into the distance. Here you can watch water boil,

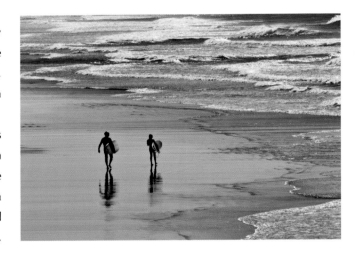

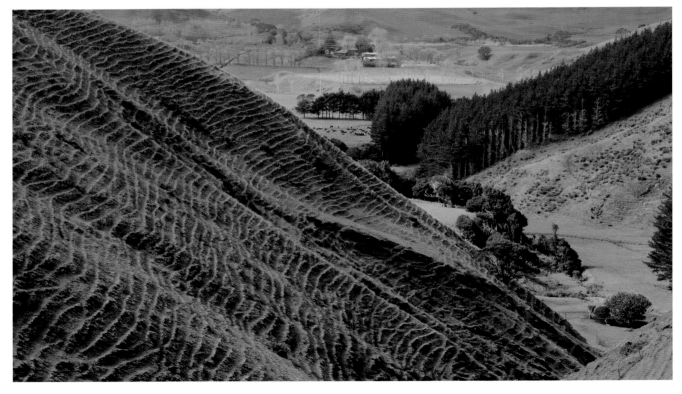

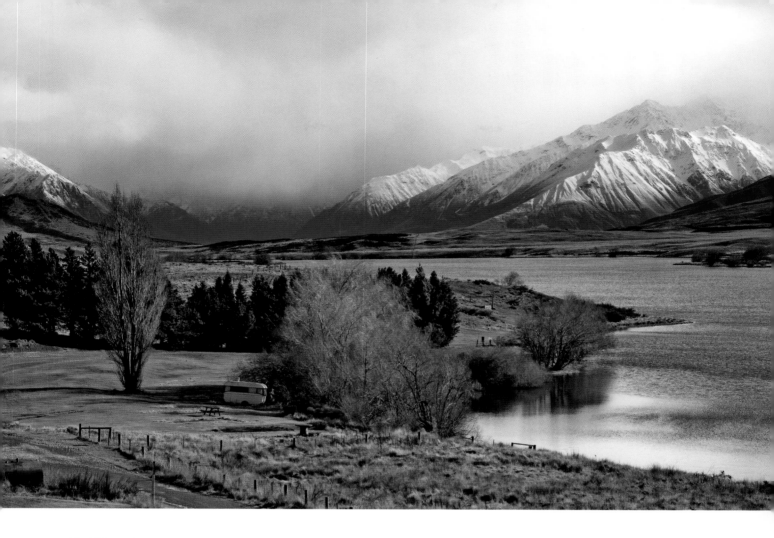

mud bubble and geysers form fountains in a natural thermal wonderland. Glaciers creep and creak, waterfalls thunder, and you can walk on golden beaches where hundreds of seabirds call and the only footprints are yours.

There are forests of filmy emerald tree ferns to stroll through, giant kauri trees whose branches reach heavenward and rainforest festooned with skeins of spooky hanging moss. Here the birds' dawn chorus is unlike any other.

In New Zealand you can snowboard in the morning, catch a trout for lunch and surf on some of the world's best waves in the afternoon. And, at night, clear, unpolluted skies make star-gazing a universe-expanding experience.

The land area of New Zealand is only a little larger than that of the British Isles but the total population is 4.7 million. It's easy to go-bush, leave the busy, complicated world behind and relax in isolation.

The pristine natural environment makes New Zealand an adventure tourism destination for backpackers. The golf courses, gardens, fine dining, the cultural activities of the bigger cities and the easily accessible natural beauty, make it an attractive and unhurried holiday for the not-so-young.

There is something for everyone in this splendid, faraway place.

Above: Lake Clearwater in Canterbury with the Southern Alps in the background.

Opposite top: Surf is up at Te Ārai Beach in Northland.

Opposite below: Pasture on steep and rolling hills at Āwhitu near Auckland.

Geography and Climate

If a cosmic wizard picked up New Zealand and placed it in the same but opposite latitude and longitude in the Northern Hemisphere, it would stretch from Brittany, in France, to Casablanca in Morocco. If, in Auckland, one drilled a hole precisely through the middle of the earth it would come out near Seville in Spain.

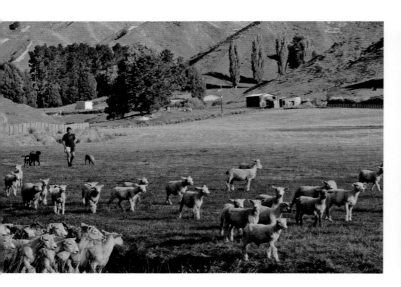

New Zealand has two main islands. It is 1,100 km (684 miles) from the top to the bottom of the North Island and 900 km (560 miles) from the top to the bottom of the South Island. Castle Rock, in the Dunstan Range in the South Island, is the furthest place from the sea being 120 km (75 miles) from both the east and west coasts. In short, it is a long, thin country and the ocean is never far away. This geographical length gives it a huge climatic range from subtropical, in the far north, to temperate verging on chilly in the deep south.

The geographic and climatic diversity is increased by the fact that New Zealand is situated on the edge of two great tectonic plates. The Pacific plate and the Indo-Australian plate, two massive slabs of the earth's crust, meet beneath our feet. The meeting is not harmonious and

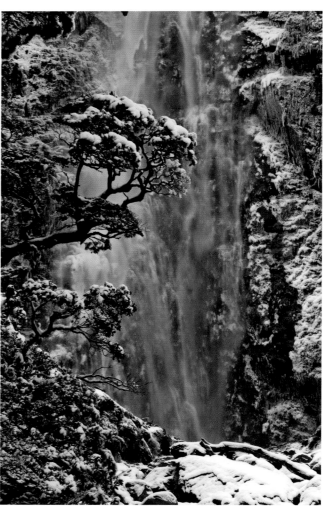

Above left: *Some of New Zealand's 60 million pasture-fed sheep in Taranaki*

Above: *A mid-winter frozen waterfall, Arthur's Pass, in the Southern Alps.*

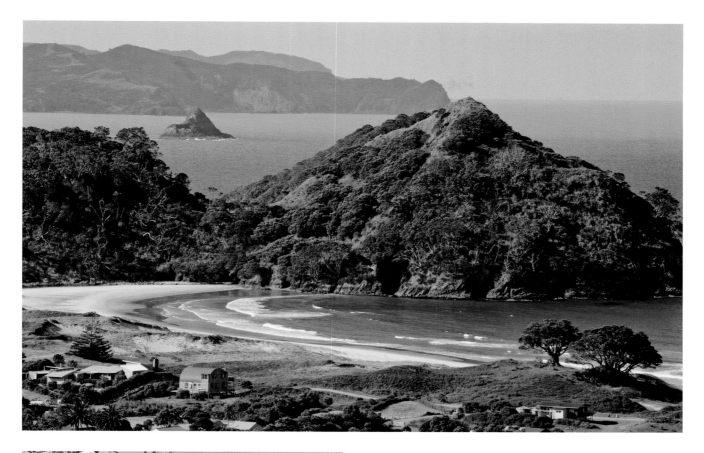

the earth, over thousands of years, rises, falls, buckles and tears. The downside of existing on the edge of tectonic plates is, in some areas, earthquakes shake houses, destroy road and rail networks, and cause landslides. Earthquakes are unpredictable in frequency and severity. They can be exciting and inconsequential or terrifying and destructive.

The upside of living in these shaky isles is that the landscape is both varied and spectacular. There are pointed, perfect-cone volcanoes, craggy snow-covered alps, flat fertile plains, rolling green pastureland, deep U-shaped glacial valleys, dripping rainforest and masses of sand dunes. The diversity and beauty of the landscape are similar to what can be found in various parts of Europe but here they are conveniently parcelled in one elongated country.

Left: Tropical gardens flourish north of Auckland.

Above: The remnants of baby volcanoes on Great Barrier Island near Auckland.

History

Aotearoa, a 'long white cloud', was seen on the horizon when the first Māori sighted this land. Legend tells that Kupe, a Polynesian navigator, arrived in Aotearoa in approximately AD 925, from Hawaiki, probably in the Tahitian archipelago. But it wasn't until 1350 that the Great Fleet, eight huge canoes, brought the first mass-migration of Polynesian settlers, the ancestors of New Zealand Māori.

Ethnologists debate the Māori settlement of Aotearoa. Māori have an intricate system of oral history but did not have a written language, so over 1,000 years historic facts and legends have merged. Māori were superb navigators, brilliant astronomers and they had, and still have, a complex culture, including visual and performance art, and a rich spiritual life. They cultivated gardens growing kūmara (sweet potato), yam, taro and gourds, foraged for forest food, fished and gathered shellfish, and hunted birds. This required a settled lifestyle, communal organisation and local knowledge. Māori settled in villages based around family groups.

Europeans arrive

In 1642, Abel Tasman's ship *Heemskerck* stumbled east from Tasmania. He thought, when he saw "a large land, uplifted high", that he had found the other side of South America.

Misunderstandings between Māori and the visitors resulted in the death of four Dutch crewmen so his ship sailed back to Jakarta. The Dutch East India Company realised Tasman was thousands of kilometres west of South America so named this land Nieuw Zeeland (New Zealand), after a seafaring province in the Netherlands. *Zee* means sea. Sea land. It is appropriate.

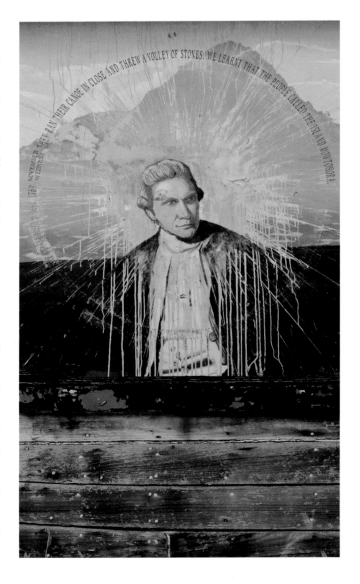

Europeans didn't return for another 127 years when, weirdly, English and French explorers, James Cook and Jean de Surville, both arrived at the same time, in 1769. Cook returned twice as did another French expedition. The race for global land acquisition was on and it was, eventually, only by hours that New Zealand became a British rather than a French colony.

In the 1790s whaling ships arrived in the north and sealing ships in the south. Sailors settled and the first intermarriage between Māori and Pākehā (European New Zealanders) began.

In 1814 a Christian mission was established in the Bay of Islands. Others soon followed. Timber for shipbuilding, flax for linen and rope, whale oil, seal oil and furs were traded for nails, trinkets and blankets but, most importantly and tragically, muskets. This resulted in terrible intertribal Musket Wars, between 1818 and 1836. Tribes with spears, mere and other traditional weapons didn't stand a chance against muskets.

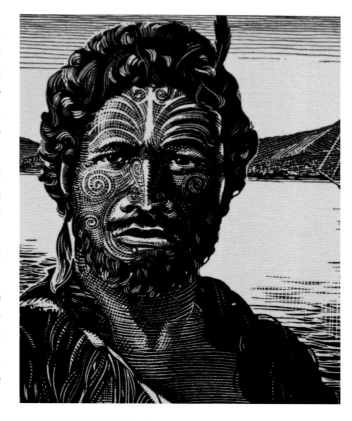

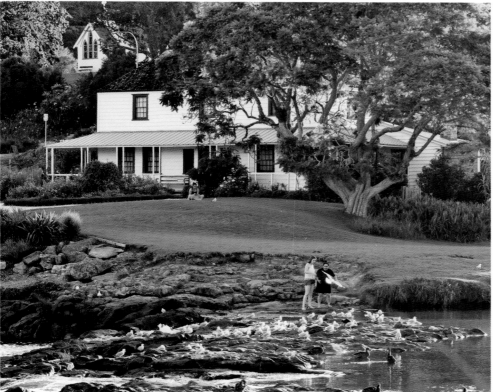

Above: Hongi Hika, a warrior chief, welcomed and traded with the first European settlers and missionaries.

Left: Kemp House, built by the Missionary Society 1822, is New Zealand's oldest European building.

Opposite: Captain James Cook was, in 1769, the first European to explore and chart the coast of New Zealand. He was entranced by it and returned three times during the next decade.

Meanwhile, the New Zealand Company, in England, began despatching shiploads of settlers. In 1837 the British government, led by Lord Melbourne, intervened to ensure that colonisation was regulated and land transactions with Māori were managed more fairly. In 1839 William Hobson was appointed the Consul on behalf of Queen Victoria. During 1840 the Treaty of Waitangi, between Hobson and a confederation of Māori tribes, was signed by 500 North Island chiefs. British sovereignty over the South Island was claimed by right of discovery. The purpose of the Treaty was to enable settlers and Māori to live together under a common set of laws or agreements while recognising Māori rights to their land, forest and fisheries. But, despite the Treaty, land continued to be unlawfully sold to settlers and the colonial government continued to treat Māori disrespectfully. Land wars followed and inevitably, Māori lost.

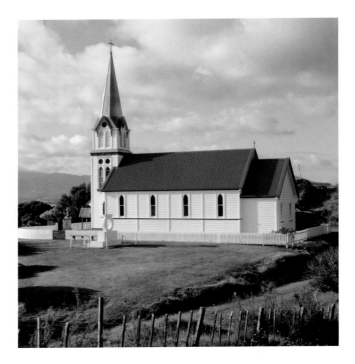

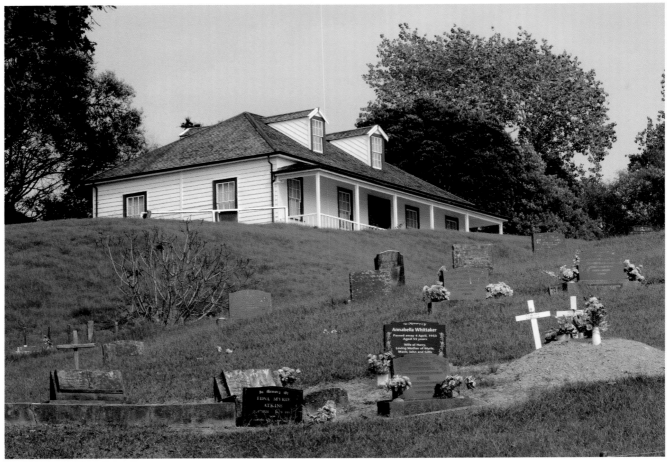

However, Māori never forfeited their Treaty rights and, today, this same Treaty governs the relationship between Māori and Government. In the last 30 years retrospective legal application of the Treaty has forced Government to address and compensate for land-related grievances by returning land or through massive financial pay-outs.

After 1900 New Zealand's history was closely linked to British history then, after 1973, to world history. The two Great Wars each claimed the lives of a decade of young Kiwi men. During the First World War, from a total population of 1 million, 60,000 became casualties, mostly on the killing fields of France.

New Zealand was the first country to give women the vote (1893) and the second to introduce an old-age pension (1898). It remains proud of being an egalitarian society, though this concept is being strained by the growing disparity between rich and poor.

New Zealand's loyalty to, and love for, Britain was challenged in 1973 when our Mother Country joined the European Union and Kiwi had to look for other markets to trade their meat, wool and dairy products. New Zealand grew up then and became economically independent quickly. It turned to Asia for trade. Though there is still a little-England underlay, the main cultural and culinary influences, now, come from closer neighbours, Asia and Pacific-rim countries.

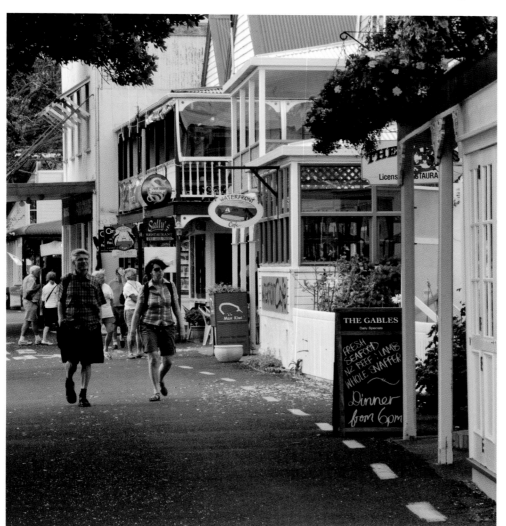

Left: Russell, New Zealand's first European town, is now a sweet water-side village in the Bay of Islands.

Opposite top: The church of Our Lady of the Assumption, in Motukaraka, by the Hokianga Harbour. This area was an enclave of French Catholicism among predominantly English Protestant missionaries to Māori in the late 18th century.

Opposite below: In 1840 Mangungu Mission House was the venue for the largest signing of the Treaty of Waitangi. Several thousand Māori arrived by canoe for formalities while 64 chiefs signed the Treaty.

People

There are 4.7 million Kiwi spread over a land area only a little bigger than the United Kingdom. There is a vast amount of space, particularly in the South Island. Auckland is the biggest city with 1.4 million people and is the only city where apartment living is well established. Otherwise, freestanding houses, often wooden with corrugated iron roofs, front gardens and vegetables gardens at the back, are the norm.

There are almost as many different ethnicities in New Zealand as there are countries in the world though 70 per cent of the people are Pākehā (of European ancestry), 15 per cent are Māori, eight per cent Asian and seven per cent Pacific Islanders. Auckland has, by far, the biggest Pacific Island population of any city in the world.

Within this diverse ethnicity there are regional variations. The South Island is predominantly Pākehā, whereas Auckland is multi-cultural with half its people being Polynesian, Asian and all sorts of other ethnic mixes. Eastland and Northland are both areas with a high Māori population. Interracial marriage is common and has been

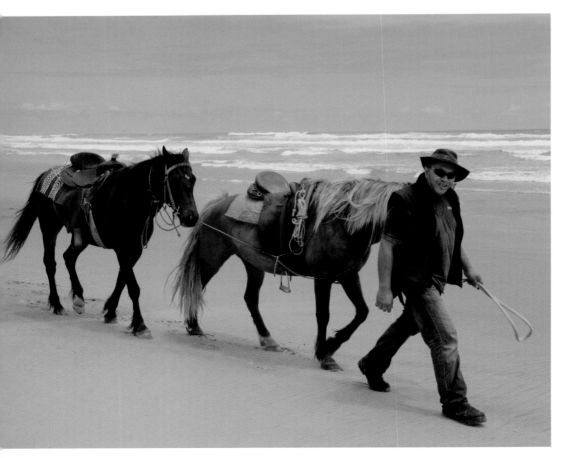

Left: Rod Penney hosts horse treks from Mititmiti in Hokianga.

Opposite left: Trying out a new tractor at Fieldays, a massive farmers' fair.

Opposite top right: Cycling the wine trail in Martinborough, Wairarapa.

Opposite below right: Winners of the pet lamb competition at the Bay of Island's Pastoral Show. Such shows are held annually in most rural areas of New Zealand.

since the first settlers arrived. Recent Asian immigrants have added to the interracial melting-pot, especially second generation children who meet at school and university, at the age when love and cross-cultural interest are in the air.

Though New Zealand is an independent country, the British Monarchy still enjoys enormous support and remains the symbolic Head of State. There is little enthusiasm to sever this final link and become a republic. Queen Elizabeth is hugely respected as are Princes Charles and William.

The geographic isolation, and 175 years since British settlement, has led to idiomatic and distinctly accented English. Some vowel sounds merge and why pronounce the last letter of a word if you don't need too? *"That's good,"* becomes *"thet's god,"* and *"thank you"* becomes *"thang yee."*

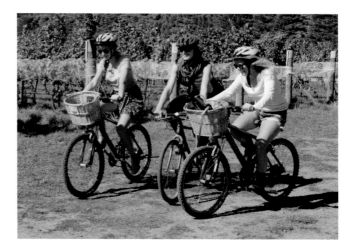

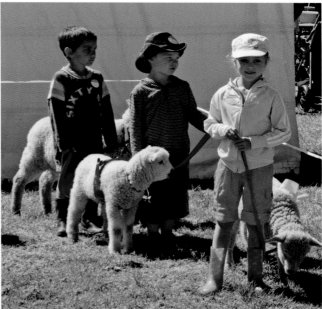

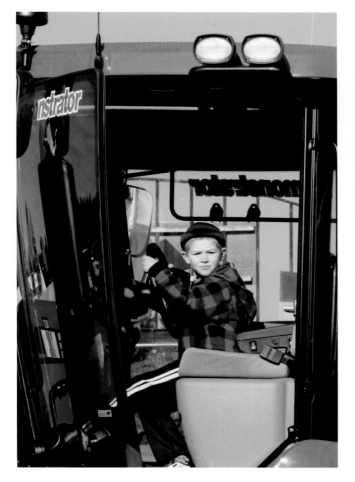

The second verse of the national anthem encapsulates the spirit of this isolated island place.

Men of every creed and race,
Gather here before Thy face,
Asking Thee to bless this place,
God defend our free land.
From dissension, envy, hate,
And corruption guard our state,
Make our country good and great,
God defend New Zealand.

Māori

Below: Koriniti Marae alongside the Whanganui River, central North Island.

Bottom: This is what the boys from the Mātaatua Marae, in Whakatāne, do on a warm summer weekend.

Māori, the *tangata whenua*, the 'people of the land', have more importance and influence culturally and politically than other ethnic minorities. The Treaty of Waitangi, the founding document, is a broad statement of principles on which the British and Māori made a political compact to establish a national state and build a government for all.

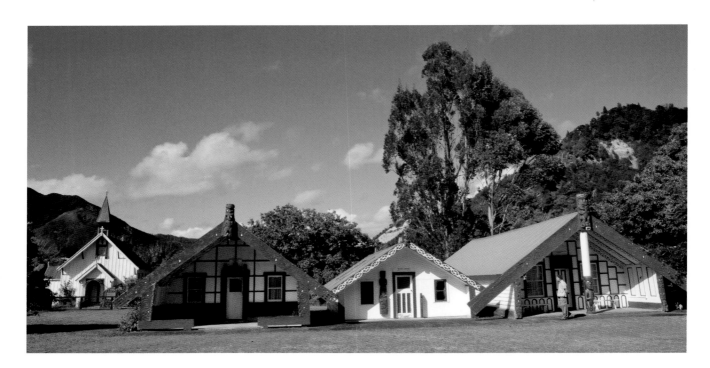

The Treaty of Waitangi is not part of New Zealand domestic law, except where its principles are referred to in Acts of Parliament. The right to determine the meaning of the Treaty rests with the Waitangi Tribunal, a commission of inquiry created in 1975 to investigate alleged historical breaches of the Treaty by Government.

Te reo Māori (the Māori language) is an official language as well as English. Many place names are Māori and many Māori words are incorporated into New Zealand English, for instance, *kai* for 'food', *kia ora* for 'hello', *whānau* for 'family', *tapu* for 'scared', and *kia kaha* for 'be strong'.

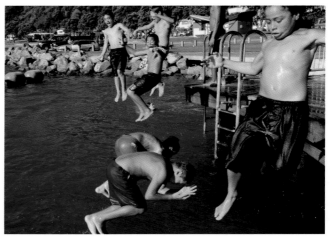

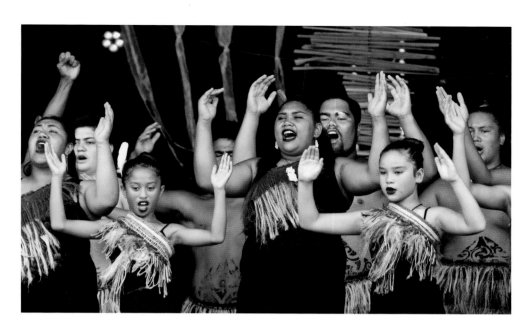

Left: Māori culture and arts is celebrated at the Ngā Puhi festival in Kaikohe, Northland.

Below: The guardian of Lake Taupō with the volcanoes, Mt Ruapehu and Mt Ngauruhoe, in the background.

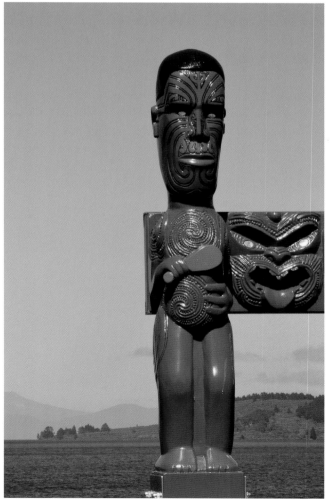

Te reo is a vital part of Māori culture and a defining feature of Aotearoa/New Zealand's education system. Twenty per cent of students learn te reo in school, in English medium, and three per cent attend *kura kaupapa Māori*, state schools that teach in te reo, with philosophies and practices that reflect Māori cultural values.

Māori arts, crafts and *kapa haka* (performing arts including dance and haka) are not just rolled out for tourists, though one might think so when visiting Rotorua. They are an integral part of Māori and thus New Zealand culture. There are inter-tribal *kapa haka* competitions each year, secondary schools have a national *kapa haka* competition attended by thousands of competitors and spectators, and larger tribes have weekend cultural festivals each summer.

Each tribe has a *marae*, commonly owned land with numerous buildings and a flat area in front of an impressively carved traditional meeting house. *Marae* are private and sacred places that should be treated with great respect. Visitors are often welcome to visit them but should not enter without seeking permission.

There are few Pākehā families without Māori members and even fewer Māori families without Pākehā ancestors. In the last 30 years Māori culture has had an increasing influence on what it means to be a New Zealander.

Cuisine and Beverages

New Zealand truly is the land of milk and honey, both of which are lucrative exports; as are beef and lamb, fish, fruit and vegetables. With few natural mineral resources the prosperity of this country depends on exporting food to the world. And New Zealand is a leader in efficient and sustainable agricultural, forestry, horticultural and fishing practices.

Sheep and cattle are farmed on the hills, graze freely all year round and are entirely grass-fed. Because of this beef and lamb are high in protein, low in fat and of incomparable tenderness and flavour. Likewise venison, a lean meat, is both farmed commercially and hunted (with permits) in the wild. The flatter pasture land is the place for dairy cows and 5 million of them produce 21 billion litres (37 billion pints) of milk each year. This is turned into milk powder, baby food, whey products, cheese, butter and ice-cream, most of which is exported. Ice-cream is famously cheap and creamily delicious.

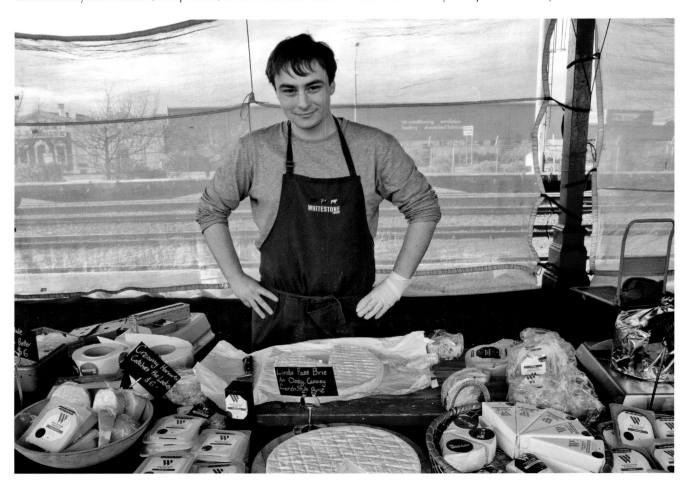

And, as this island nation is fully wrapped by ocean, seafood is important. The fishing industry is sustainable and tightly controlled, so when you tuck into a fat fillet of fish you can do it without eco-guilt. Aquaculture, primarily for Green Shell Mussels and salmon, is undertaken in pristine seas. New Zealand salmon tastes of pure, cold, southern ocean.

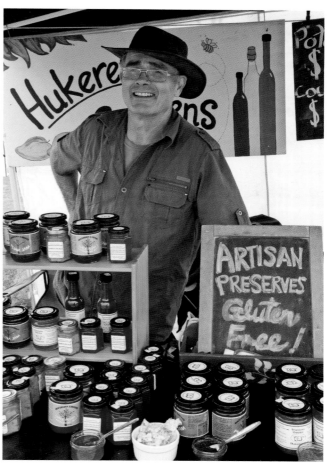

Fruit is seasonal and eaten fresh, just the way Kiwi like it. You can't buy strawberries and cherries in winter or peaches in spring. But when favourite fruits are in season, they are picked when ripe, go to the market quickly and taste of sunshine. Kiwifruit, another important export, is abundant, cheap and available all year round and citrus is plentiful in most seasons.

Left: Viand's Bakery, Kihikihi, central North Island, is twice winner of the New Zealand Supreme Pie Competitions.

Above: She made it and he sells it. Fresh preserves at the Old Packhouse Farmers' Market in Kerikeri, Northland.

Above left: It's true. It is easy to catch trout in the Inangahua River, Reefton.

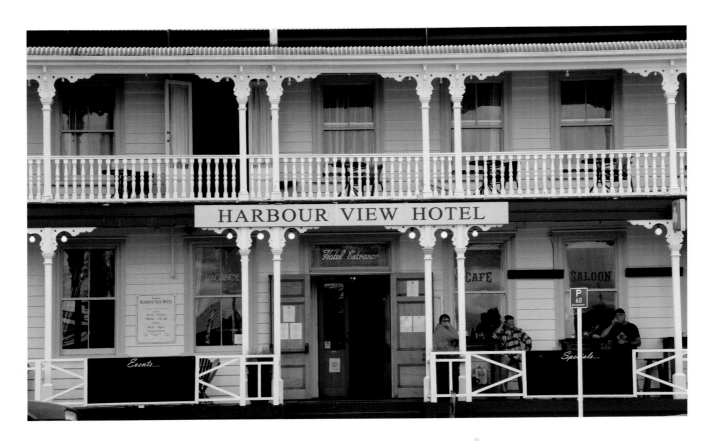

Visitors to New Zealand find a culinary mix-up. Old-style food inherited from British ancestors lives on; fish and chips, mashed potatoes, pies and scones are widely available. Each year bakeries have a hard–fought and proudly won 'best pie' competition. New-style food, introduced in the last 30 years by recent immigrants from Asia, has added fresh, fast wok-cooked meals from Thailand and China, spicy curry delights from India and amazing sushi and sashimi, in the Japanese tradition, from fresh local seafood.

These influences make a multi-faceted cuisine and on many restaurant menus items recall food traditions from other countries but are prepared with a Kiwi twist. This is fusion food that is, above all, fresh and local.

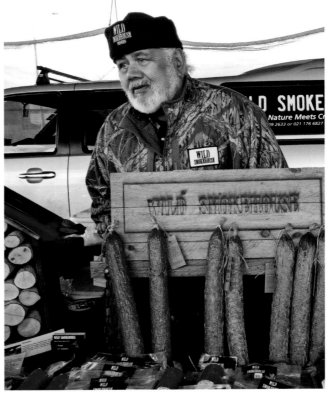

Above: A heritage hotel in Raglan, west coast, North Island serves fusion food, fresh fish and artisan beers in the bar and restaurant.

Right: Smoked produce at the Sunday Farmers' Market Dunedin.

Opposite: A café in Eat Street, Rotorua.

Beverages

Kiwi know coffee and 'instant' no longer ticks the boxes. You won't find any American-style drip-coffee here either. At home coffee is either made with a plunger or an espresso machine. Town folk often go to the local café for their daily fix and young people become baristas with dedication and style.

Tea, a beverage inherited from the British, is still prevalent though its consumption has been outpaced by coffee. Tea drinking, too, is evolving so that green and herbal teas are becoming increasingly popular. Green tea grows in some areas and is exported.

New Zealand stretches over similar latitudes to France, Spain and Italy, though in the Southern Hemisphere, and has diverse terrain and climate. This means that grapes grow and wine flows. There are 10 distinct wine-growing regions, each with their own terroir, climate and wine characteristics. If ruby red pinot noir is your favourite, the best comes from the South Island and if sauvignon blanc is the white wine of choice, that would come from Marlborough, Nelson or Wairarapa. Chardonnay from Hawke's Bay wins many world wine awards. Wine is New Zealand's tenth most lucrative export and wine-loving visitors come here especially to wine tour.

Beer was the first alcoholic beverage brewed in New Zealand. It was cheap and the pub culture arrived with British settlers. Beer drinking reached a peak in 1984 but consumption has halved since then. Beer during a work-day lunch break has long gone and male-dominated swill bars are very last century. Mass-produced beer has given way to many different boutique brands.

Natural Habitats

Opposite: Glendu Bay, Lake Wanaka, looking north towards Buchanan Peaks.

Ew Zealand is blessed with a huge variety of magnificent landscapes and a low population that is acutely aware of its outstanding natural beauty. Consequently, one third of the land is protected by law, and maintained and managed as reserve areas, usually by the Department of Conservation or local councils. Protected areas include national parks, conservation parks, nature reserves, scientific reserves, scenic reserves, marine reserves and historic reserves.

Below: Pōhutukawa in flower in Māhūrangi Regional Park, near Auckland.

The best known of these areas, and those to which visitors are most attracted, are the 13 National Parks which make up 11 per cent of the land area. These include the spectacular sounds of Fiordland, Aoraki/Mt Cook (the highest mountain), Tasman, Franz Josef and Fox Glaciers, the volcanoes of central North Island, the golden coves and forested headlands of the Abel Tasman National Park, the near-perfect volcanic cone of Mt Taranaki and the forests along the Whanganui River.

National Parks provide outstanding opportunities for walking, skiing, hiking, kayaking, photography, mountaineering and other outdoor recreations. They contain most of the tracks designated the '8 Great Walks'

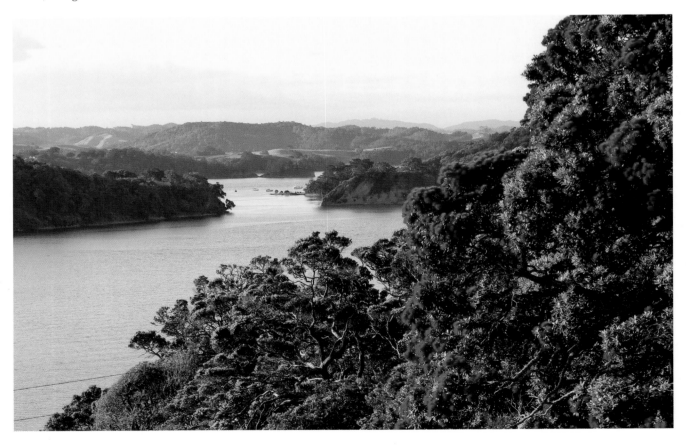

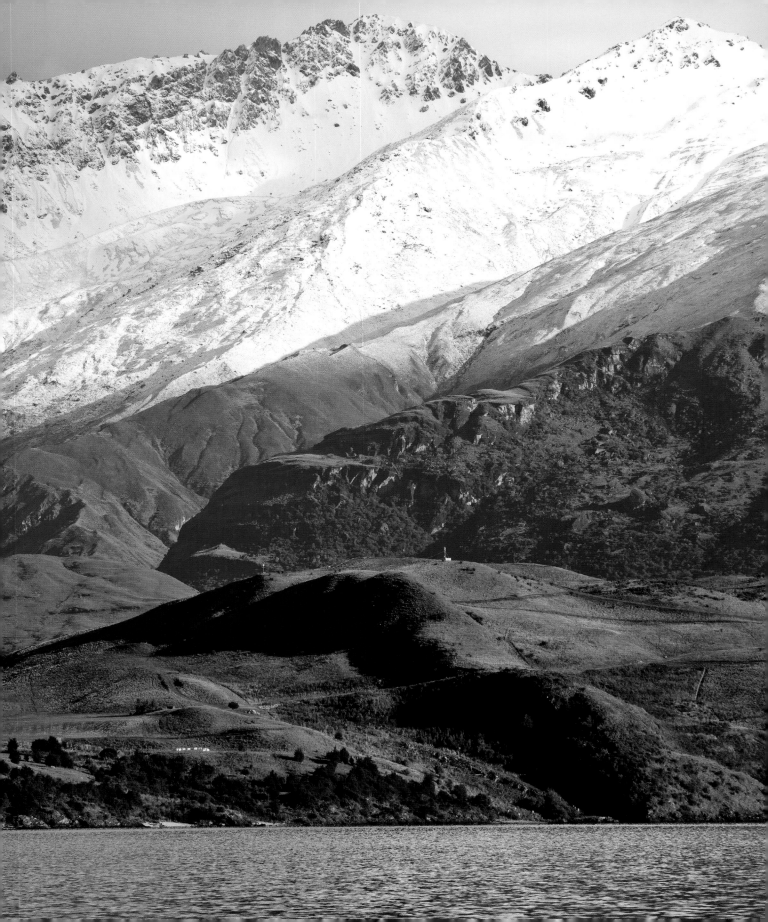

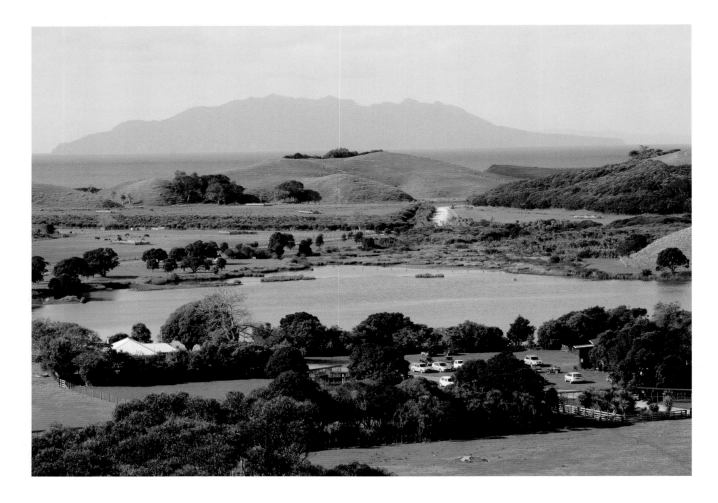

(the Waikaremoana, Milford, Kepler, Routeburn, Rakiura, Heaphy, Abel Tasman and Tongariro Northern Circuit walks) as well as the canoe trip down the Whanganui River, a 'Great Journey'. Two of these areas, Te Wāhipounamu (an amalgamation of National Parks and Scenic reserves in south-west New Zealand) and Tongariro National Park, are protected as places of outstanding universal value by UNESCO.

Te Araroa (The Long Pathway) is New Zealand's long-distance hiking trail. It stretches some 3,000 km (1,865 miles) from Cape Rēinga to Bluff, along the length of both the North and South Islands. Hiking the full length of Te Araroa takes from three to six months. It is something that is on many younger New Zealanders' bucket-lists and others, who don't have the time to walk the path in one big effort, do it in sections. Visitors are welcome to join Te Araroa at any point; it is inexpensive and shared hiking huts provide accommodation along the way.

Likewise, Nga Haerenga, a network of over 2,500 km (1,550 miles) of dedicated cycle trails, will soon be linked so that they stretch the length and breadth of New Zealand.

Kiwi love the outdoors and every weekend, in summer, there is an exodus of people from the towns to the beaches, mountains, rivers and lakes. In the winter the exodus is to ski fields of which there are two big ones on Mt Ruapehu, an active volcano in the central North Island, and 24 ski fields of different sizes dotted up the length of 500 km (310 miles) of the Southern Alps.

Thrill-seeking visitors can titillate their adrenalin in many ways. Bungy jumping was invented here and so was zorbing and jet boating. Then there is white-water rafting, skydiving, canyoning, parapenting, heli-skiing and more.

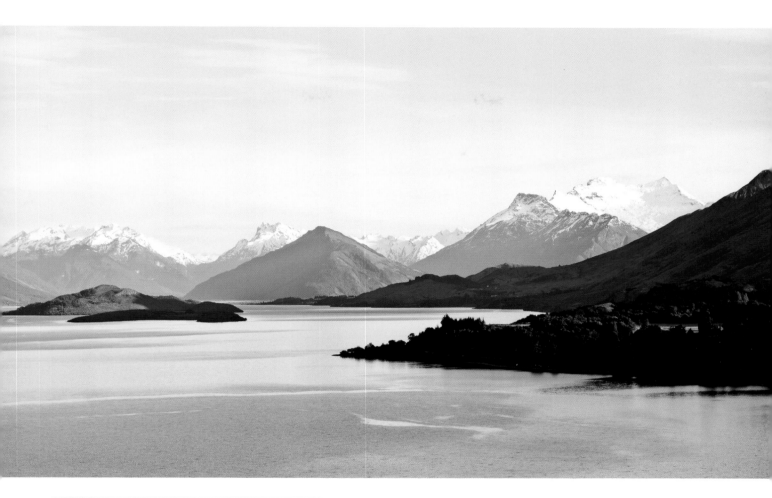

Above: Lake Whakatipu, looking north towards Mt Aspiring National Park.

Left: Māhūrangi Harbour, near Auckland, is a fine place for kayaking, swimming and picnicking.

Opposite: Tawharanui Regional Park, near Auckland, well known for birding, swimming and surfing.

Flora and Fauna

Plate tectonics worked in such a way that New Zealand separated from Australia and drifted into the Pacific Ocean 35 million years ago. Now the two countries are separated by the Tasman Sea. This separation from other land masses, the extensive altitude difference from high alpine to sea level and the long north-south latitudinal reach of the land have led to the evolution of a unique and rich indigenous flora and fauna.

Flora

There are 2,418 indigenous vascular plants, approximately 560 mosses and 2,300 species of lichen. More are being discovered. Of these indigenous plants 80 per cent of trees, ferns and flowering plants are endemic, that is, found only in New Zealand.

Fifteen per cent of the total land area is covered in indigenous plants and that proportion is increasing as New Zealanders appreciate the rarity and value of their unique flora and its varied habitats.

In the far north there are tall kauri and kohekohe forests. Podocarp rainforest in the central North Island is dominated by other forest giants: rimu, miro, mātai, tōtara and kahikatea. The South Island has thousands of hectares of moss and lichen-laden beech forest. There are also dune

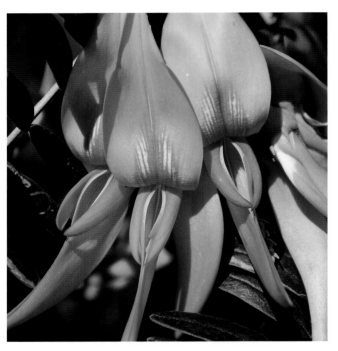

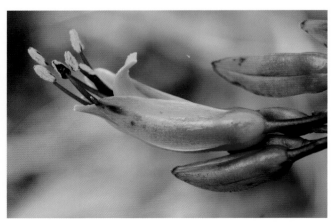

lands dotted with spinifex and pīngao, fields of alpine herbs and flowers, high dryland tussock and extraordinary areas of ferns.

Ferns are an iconic and revered element of national identity. They feature, along with the kiwi, on one dollar coins, the silver fern is an alternative national flag and is on the uniforms of national sports teams. There are 200 species of fern from ten-metre (30-foot) tree ferns to filmy ferns less than a centimetre (third of an inch) long. They often form undergrowth beneath a dense forest canopy, hang like curtains along banks and decorate trunks of larger trees.

There are few deciduous trees or annuals but bright flowering trees and vines are much loved. Coastal pōhutukawa, our Christmas tree, bursts into scarlet blooms in late December, kōwhai trees fill forests with their golden blooms in spring, clematis clambers over other trees with a veil of bright white flowers and harakeke (flax) plants sprout tall stalks of bright flowers every summer.

The diversity of the landscape is paralleled with a diversity in indigenous flora and visitors who are interested in plants discover an abundance of botanical treasures.

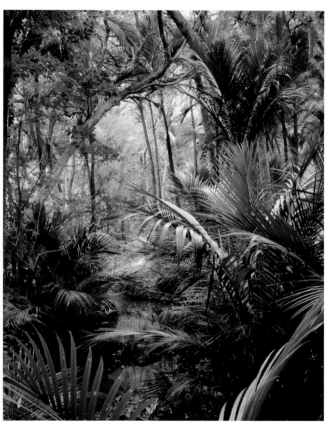

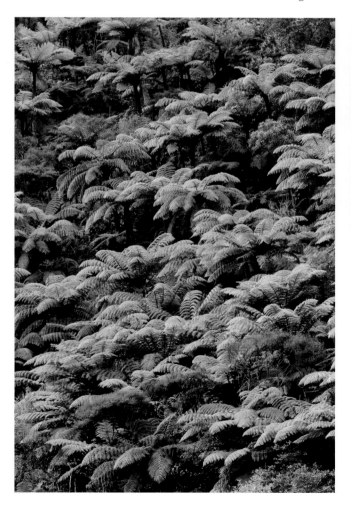

Above: A nikau palm glade at Tawharanui Regional Park.

Left: A grove of tree ferns in Taranaki.

Opposite top: Kākā-beak, a bright indigenous plant.

Opposite below left: Pōhutukawa, the New Zealand Christmas tree, blooms red in December in the coastal areas of North Island.

Opposite below right: Harakeke, a giant species of flax, flowers from November through to February.

Fauna

New Zealand has only two indigenous land mammals and they are both bats. They live deep in the forest and are seldom seen. Sea mammals living on and around the coast include seals, sea lions, nine dolphin species and 13 whale species. Whales range in size from right whales (6.5 m/21 ft) to the blue whale (27 m/88 ft). These are all protected animals and are often seen on whale- and dolphin-spotting trips and coastal walks.

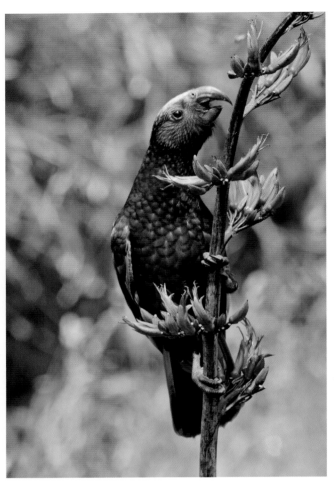

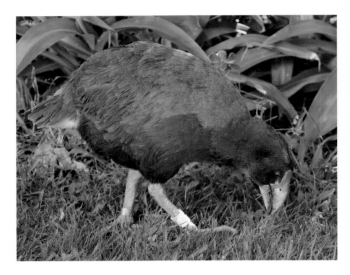

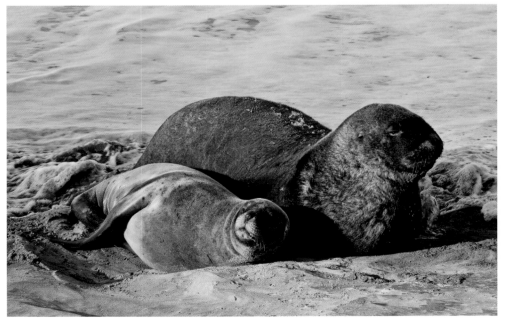

Above left: Takahē a stocky swamp hen, is too friendly and tasty for its own good. It nearly became extinct but is now fiercely loved and protected.

Above right: A kākā, a cheeky and noisy parrot, lives in the mountainous South Island and on off-shore islands.

Right: Two lazy sea lions dozing on the beach on Otago Peninsula.

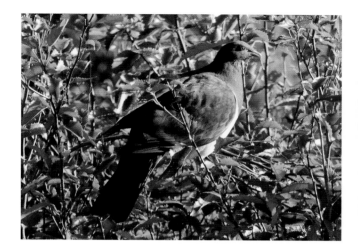

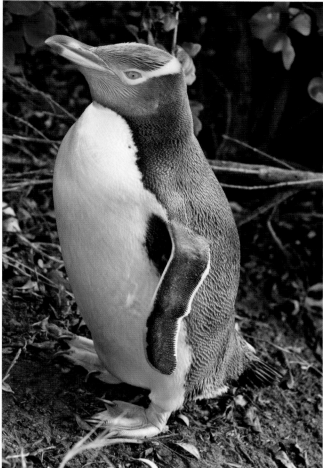

Indigenous birds were once plentiful and New Zealanders hope they will be again. Captain Cook, when he first visited, wrote enthusiastically of the sound and beauty of the dawn chorus. Birds were historically a prime food source for Māori, farming caused habitat loss and predation by introduced species such as rats, cats, stoats and weasels has resulted in some bird species becoming extinct and numerous more being threatened with extinction.

But, in a massive back-from-the-brink conservation programme many endangered birds are being saved including the takahē, kākāpō, kōkako and kiwi. Individuals, communities, businesses, as well as the Department of Conservation, are making a huge effort in habitat protection and predator extermination to ensure indigenous birds fill the forests with song again.

Visitors will commonly see kererū (giant pigeons), kākā (large parrots), tūī (white-throated songsters) and the bellbird, whose tiny size belies its magnificent chiming song and flitting fantail that follows walkers down forest tracks.

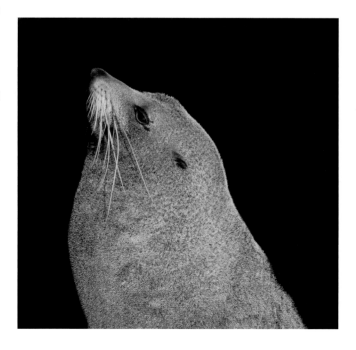

Above left: Kererū, a large indigenous wood pigeon, is commonly found in forests.

Above right: A yellow-eyed penguin that will build its nest in the bush on the Otago Peninsula.

Right: There are many fur seal colonies in isolated parts of New Zealand's coastline.

Arts

Until the 1930s the main influences over the arts and literature were trends set in the Mother Country and our brightest and best (for example Katherine Mansfield) went to England to succeed in their chosen artistic endeavour. Since then New Zealand has been increasingly defining its own artistic and cultural identity.

Internationally, New Zealand is probably best known for producing amazing films (*The Lord of the Rings* trilogy and *The Hobbit*) but a whole range of uniquely New Zealand arts are enthusiastically supported.

The strength and direction of literature, visual arts, dance and classical music are primarily cultivated at the eight universities but are well supported by galleries, sculpture and photography festivals, dance companies, including the National Ballet, and orchestras. Arty enthusiasts invest in local art, keeping the scene alive and many wealthy patrons have left huge collections to city-owned galleries.

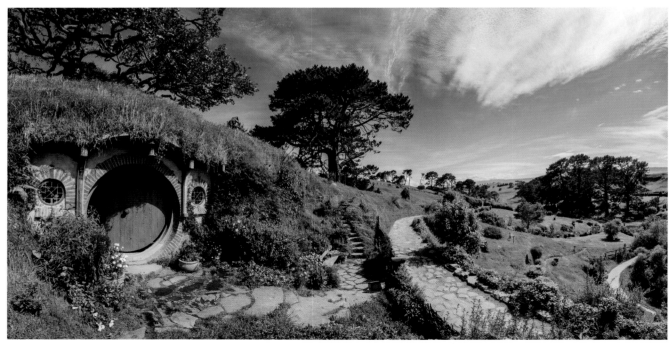

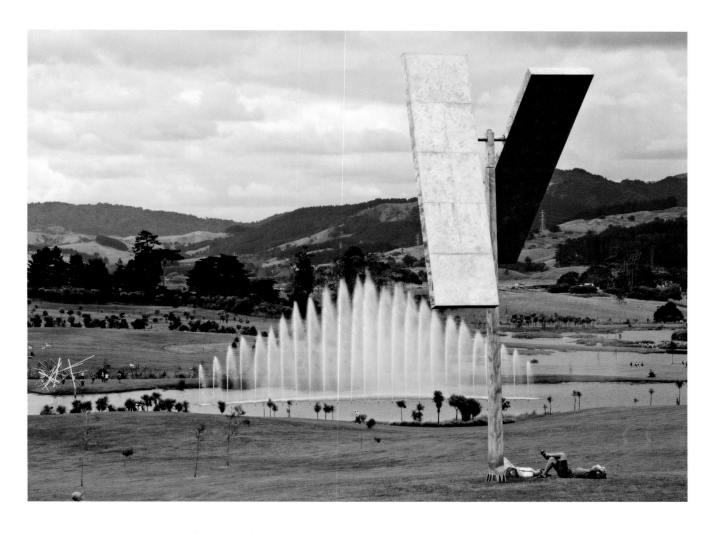

Street art is a recent trend that gained strength after the Christchurch earthquake in 2011. Hundreds of central city buildings were destroyed leaving the neighbouring buildings with large blank walls. Graffiti and street artists took it upon themselves to decorate these exposed walls, the Council supported this and Christchurch became beautiful again, in a different way. Dunedin City Council was impressed so they instigated a conscious street-art programme that is widely supported by the community. Many cities have sculpture walks and Gibbs Farm, near Auckland, is a privately owned but publicly visited sculpture collection of mammoth proportions.

Both music and visual arts are influenced by Māori and Pacific culture. Contemporary music, in particular, has Māori and Pacific rhythm and references, and visual arts often incorporate their motifs and themes.

Summer and autumn are the seasons for music and other festivals held outside in parks, vineyards and on beaches. The genre can be opera, rock, drumming and WOMAD, Taranaki's three-day World Of Music And Dance festival. There are also buskers festivals, an Art Deco festival in Napier and hot rod festivals. Winter is the season for film, writers' and photography festivals.

Above: Gibbs Farm, near Auckland, houses a huge sculpture collection.

Opposite top: Street art, and a lot of it, is encouraged in both Christchurch and Dunedin.

Opposite below: Film is huge in New Zealand. Hobbiton, the town built for the filming of 'The Lord of the Rings' trilogy and two Hobbit movies, is now open for visitors to explore. Hairy heels are not required.

Sports and Lifestyle

This is a sports-crazy country. The temperate climate, the abundance of venues and inexpensive entry costs make sport participation easy. Sports and lifestyles are inextricably intertwined as social life and friendships often link to sporting activities; the picnic on the beach after surfing, beers at the rugby club after the game, dinner around the campfire after fishing and herbal tea in a café after yoga.

Schools, most of which have grass fields for cricket and rugby, netball and tennis courts and swimming pools, start children thinking of sport at an early age. Most children are taught to swim, and learn water safety, at school. This is vital considering the country is surrounded by sea, lakes and rivers are plentiful, and water sports and beach activities are intrinsic to the Kiwi lifestyle.

Water-based sports include sailing, surfing, swimming, kayaking, windsurfing, kite boarding and diving. These activities are easy to access. It is often windy and everyone lives close to either the sea or a lake. When winter thunders in it is time to put away the surfboard and kayak, and get into skiing and snowboarding; there are plenty of opportunities for both.

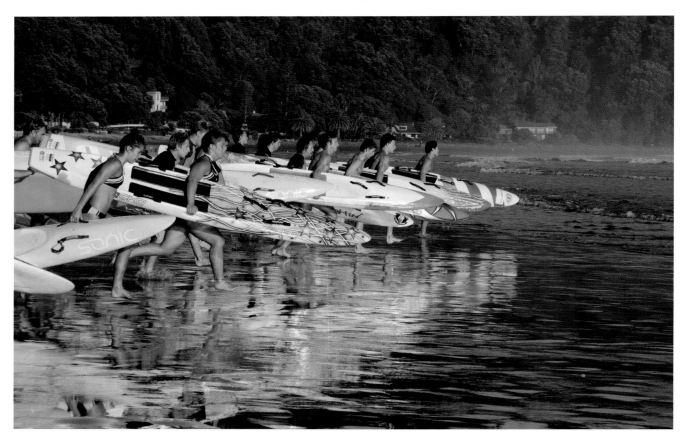

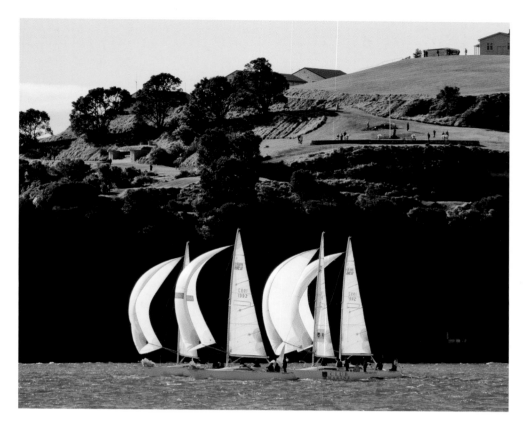

Left: *A quick spinnaker run up Auckland Harbour.*

Below: *There is nothing quite like a soak in a natural hot pool with bush all around.*

Opposite: *Surf Club is a common summer activity. This is in Ohope, a glorious surf beach on the east coast of the central North Island.*

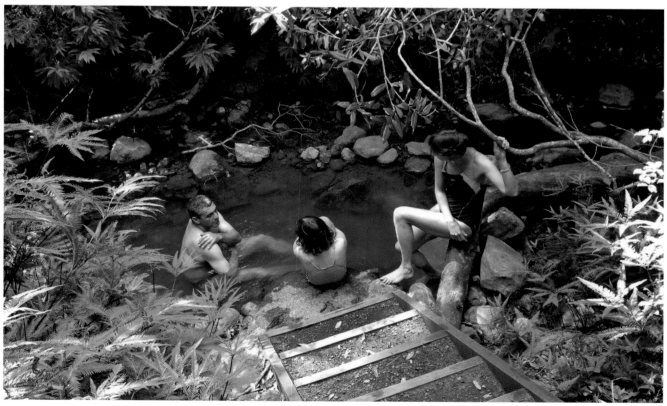

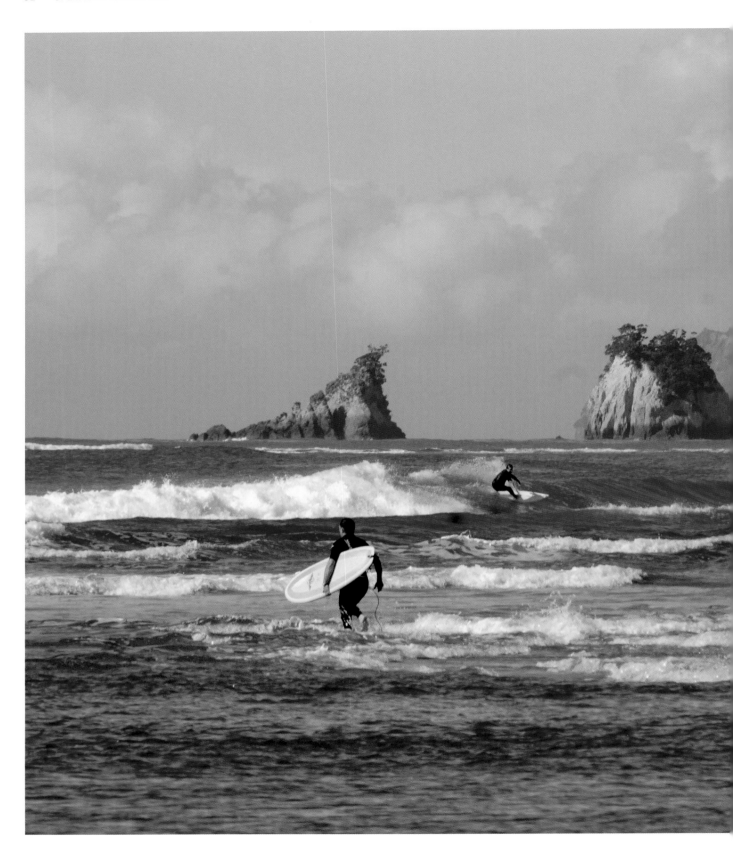

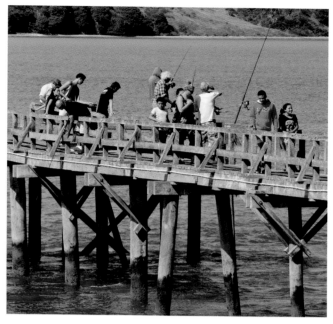

Beach-edge promenades every afternoon, whatever the season, are filled with runners, walkers and cyclists. And gym-based exercise such as pilates and yoga are increasingly popular.

Team sports also begin at school. The major ones, cricket in summer, and rugby and netball in winter, are rooted in colonial history but, as with everything, New Zealand has a unique angle to these traditional sports. In both rugby and netball Māori and Pacific Islanders excel and our national teams are proudly multicultural. New Zealand punches way above its population size in the Olympic Games and has, for decades, been winning many medals in sailing, kayaking, rowing, and track and field events.

Many young visitors come here for the surf and the snow then add a few extreme sports, such as mountain climbing, caving and skydiving, to their adventures. Older visitors come to New Zealand for hiking, golf and trout fishing, all of which are famously affordable.

Left: Surf is almost always up at Whangamatā on the east coast of the North Island.

Above: Kingfish and snapper are often caught at Pahī, a holiday village on the Kaipara Harbour.

Chapter 2: Northland

Northland is the warmest part of the country where avocadoes, citrus, kiwifruit and other subtropical fruit grow prolifically. It was the first area to be settled by the British and has a high Māori population, so it has a lot to offer in terms of Māori culture and colonial history. There are also forest hikes, surf beaches, vineyards and wonderful cycle tracks.

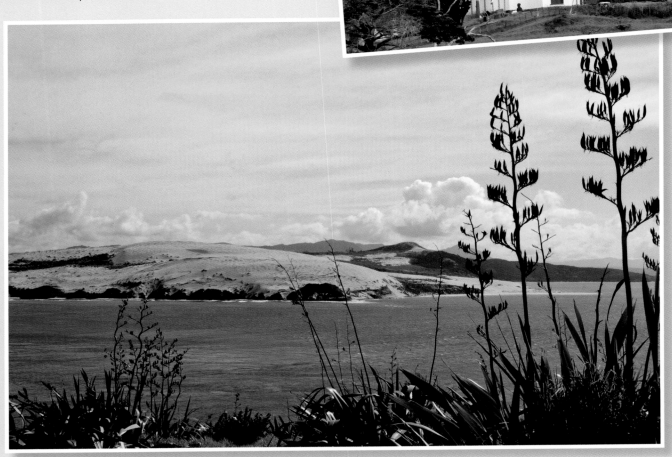

Above: Harakeke pods frame vast sand dunes on the northern side of the Hokianga Harbour.

Top: Each Māori sub-tribe has its own pretty red-roofed church, usually on a hill top.

Left: Sunny Sunday boat-launching at Pahī on the Kaipara Harbour.

Below: Charlie's Rock swimming hole on the Waipapa River near Kerikeri.

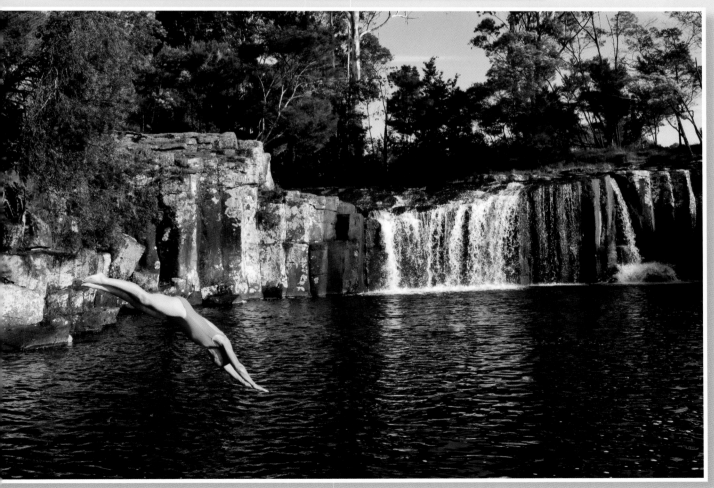

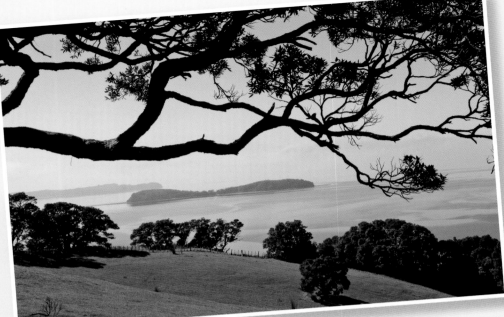

Left: Māhūrangi Regional Park in island-studded Hauraki Gulf. Eight large Regional Parks on the Gulf's Northland coast ensure that there is plenty of space for everyone to enjoy beaches, headland views and bush walks.

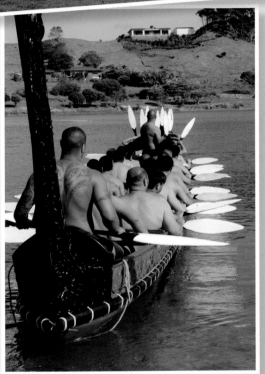

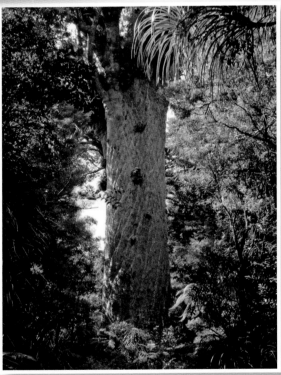

Above left: Māori traditions are an important part of New Zealand's sport, art and culture. A waka crew practise on Taipa Estuary for Waitangi Day (National Day) competitions.

Above right: Tāne Mahuta, a giant kauri tree in Waipoua Forest, is over 2,000 years old. He is revered as a forest god and is New Zealand's largest tree being 51 m (168 ft) tall and 14 m (46 ft) around the trunk.

Right: Cape Rēinga Lighthouse, the northernmost point of New Zealand.

Below: On a Mangawhai walk, a pōhutukawa tree stretches audaciously over the cliff edge, defying gravity, wind, salt spray and storms.

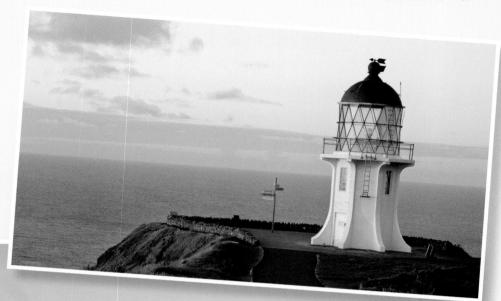

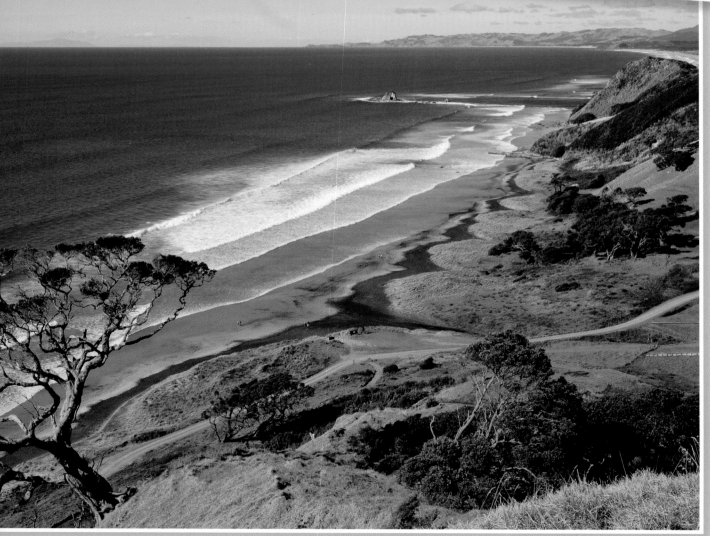

Chapter 3: Auckland

With 1.7 million people Auckland is the biggest city. The west side of the city is hemmed in by the tendrils of Manukau Harbour and beaches thread their way between headlands on the east side. It's a vibrant city and a cultural hub. There are hundreds of harbour and beach-side bars and restaurants, and ferries come and go from interesting places.

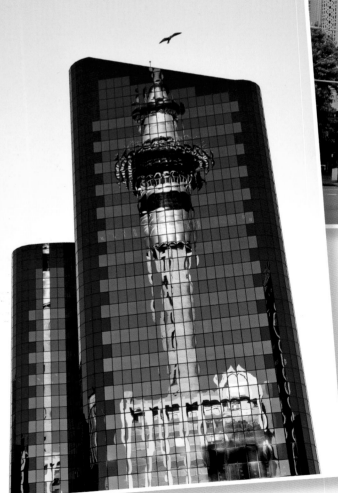

Above and left: Central Auckland has interesting architecture, both modern and heritage. It is compact enough to explore by walking and is pedestrian focused with numerous parks and lane-ways.

Opposite: Squeezed like an hourglass between volcanoes and two harbours, Auckland city centre has grown upwards. The Sky Tower, affectionately mocked for its likeness to a syringe, punctuates the skyline.

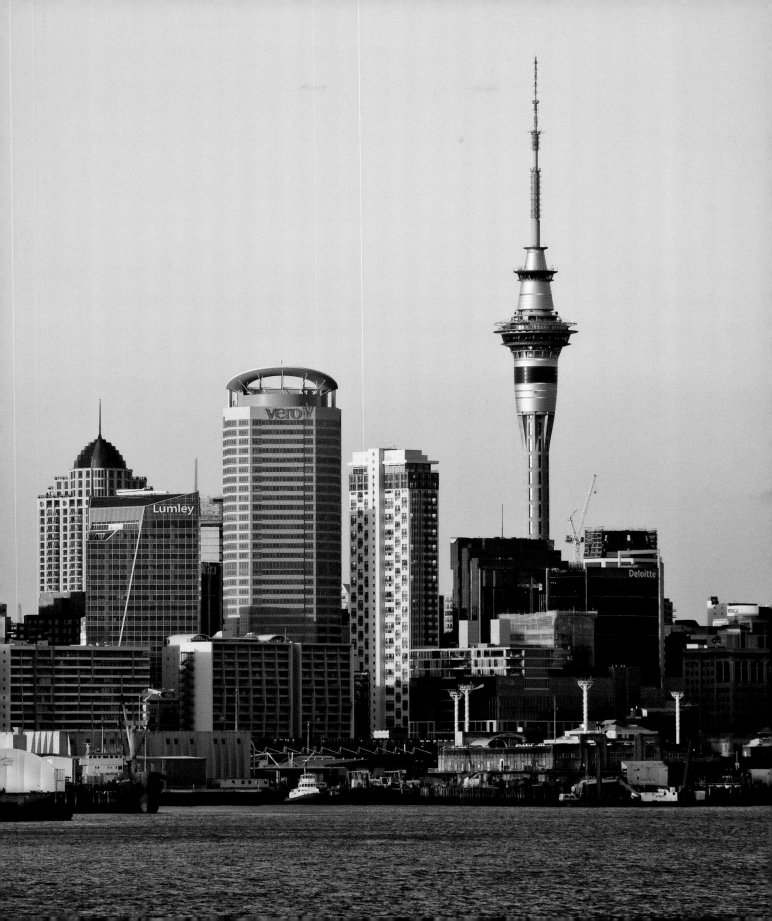

Right: *Auckland Museum, on a hill in the 75-hectare (185-acre) Domain, tells stories of what is unique to this land and its people.*

Opposite: *The Harbour Bridge is a dominant feature in this city of sails.*

Below: *Auckland Town Hall, 1911, Renaissance Revival in style, has fine acoustics and a massive, beautifully tuned, pipe organ.*

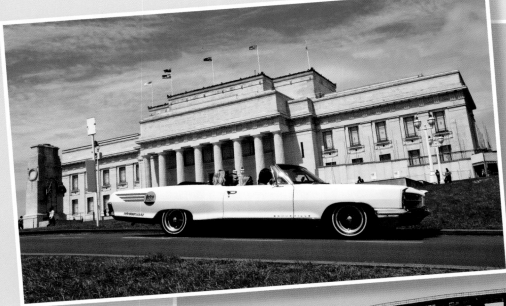

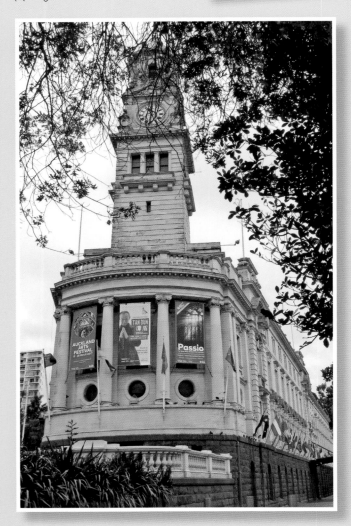

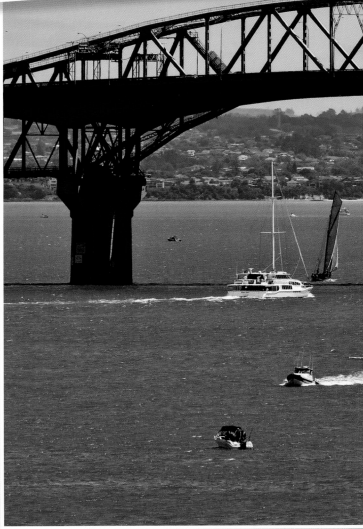

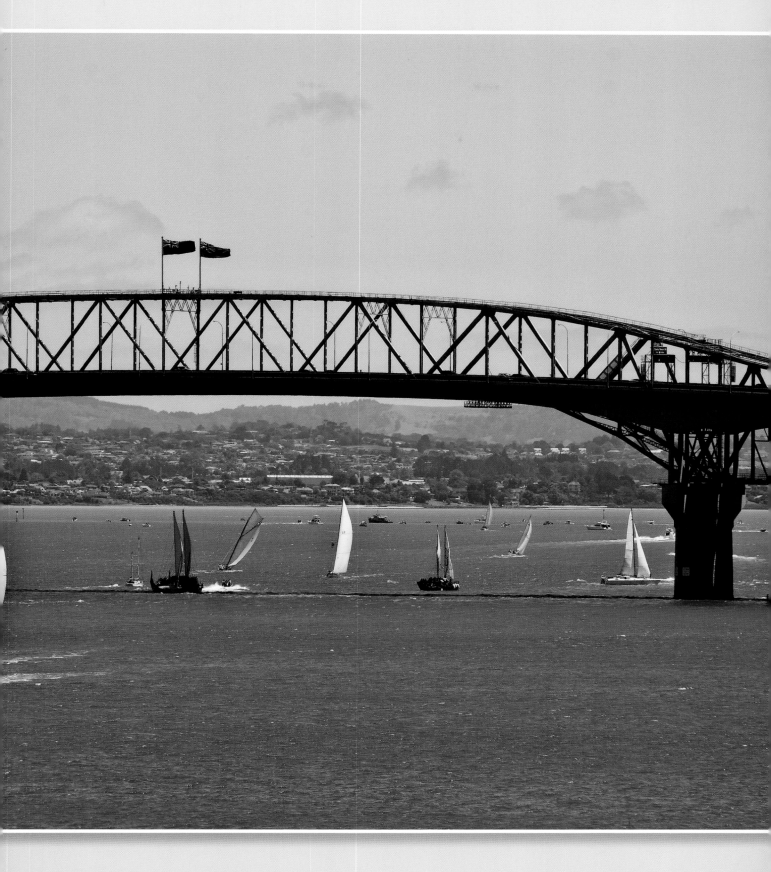

Chapter 4: Central North Island

These rugged uplands in the central North Island have Lake Taupō, New Zealand's largest lake, the Waikato River that stems from it and Tongariro National Park's three volcanic peaks. It is an active volcanic zone with all sorts of exciting hissing, bubbling and sulphur-smelling thermal activity.

Right: *Feel like leaping off a cliff? Double bungy jumping is the wild thing to do in Taupō.*

Below: *The Aratiatia Dam and rapids on the Waikato River.*

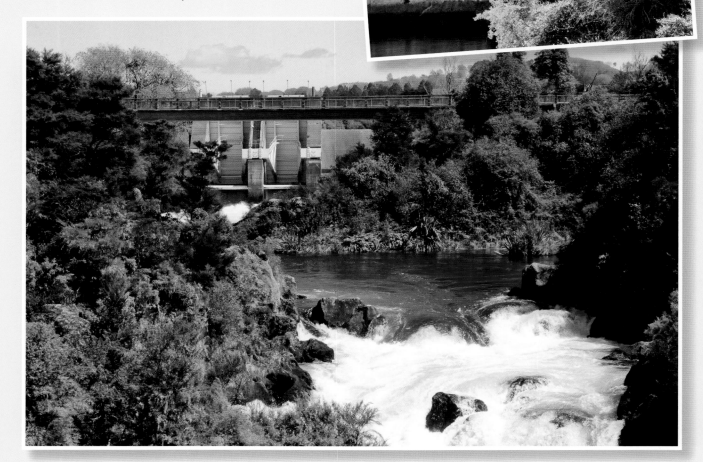

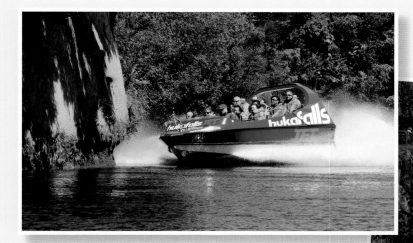

Above: A speeding Hukafalls Jet full of thrill-seekers on the Waikato River.

Right: The Waikato River squeezes into a tiny canyon 15 m (50 ft) wide creating the thundering Huka Falls.

Below: Lake Taupō, and the town alongside it, is the base for water sports in the summer and skiers in the winter.

Rotorua

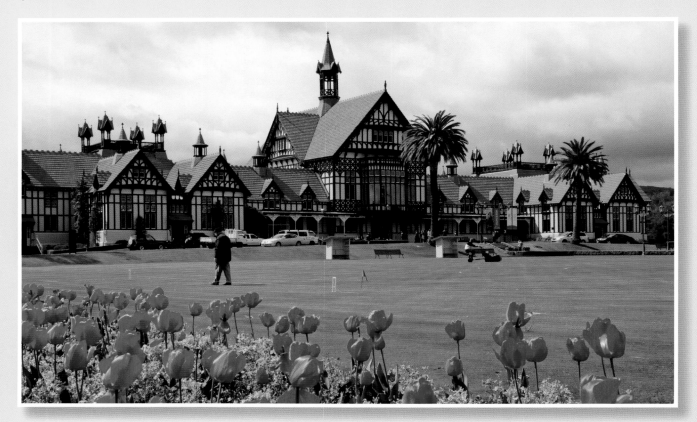

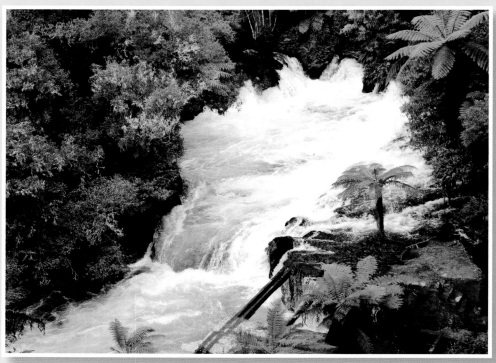

Above: Government Gardens cover 20 lake-side hectares in central Rotorua. They are a treat, whatever the season. Central to them is the splendid mock-Tudor building housing the museum and art gallery.

Right: Okere Falls on the Kaituna River, near Rotorua. There are wonderful walks with views of this bush-surrounded river, waterfalls and trout pools. It is also popular for white-water rafting.

The Volcanoes

The Central Plateau, one of the world's most active thermal areas, has volcanoes galore. Thermal features include steaming hot springs, bubbling mud, fountain-like geysers, champagne lakes and air that smells of sulphur. You can climb an active volcano, ski down one in the winter and take great walks through extraordinary moon-like landscapes.

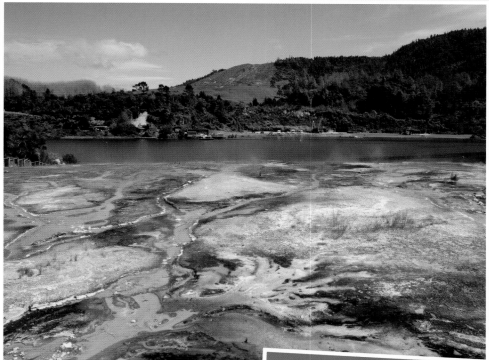

Left: Orakei Korako thermal area opens to a lake edge. Silica sinter terraces are covered in abstract patterns of orange, yellow, white, grey and blue; a colourful creation that steams, bubbles, fizzes and pops.

Hamilton Gardens

Right: Hamilton Gardens, a 54-hectare (133-acre) public park and gardens, on the banks of the Waikato River, gained international significance in 2014 when it won International Garden of the Year. It includes 21 feature gardens, representing different traditions and lifestyles, landscape vistas including a sizable lake, themed glades and numerous cultivar gardens. It is varied, big and beautiful in all seasons. The Indian Char Bagh (pictured), with a pavilion overlooking the river, represents a 17th-century Mogul garden.

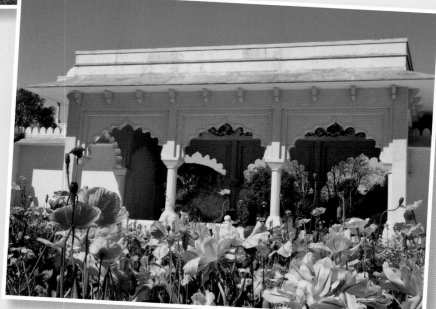

Taranaki

The near perfect cone of Mt Taranaki defines the region. It is surrounded by a National Park with hiking trails and plenty to interest flora and fauna fanciers. New Plymouth, a city between the ocean and the mountain, is a happy fusion of café culture, surfing enthusiasts and visual arts aficionados. There are two excellent art galleries and interesting sculpture walks.

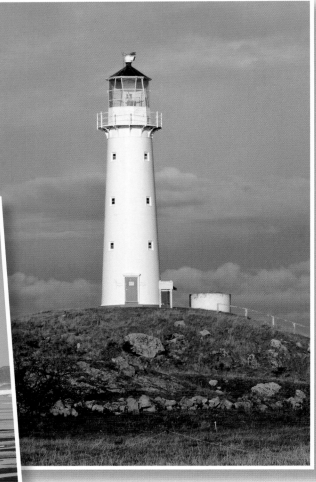

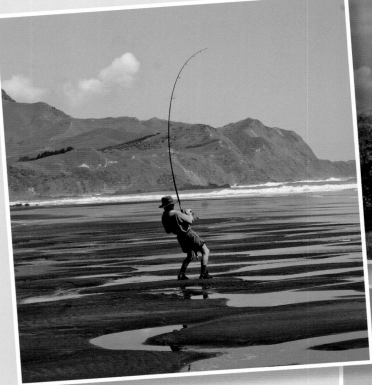

Above: This is how to catch the big one; Kiritehere Beach, North Taranaki.

Above right: Cape Egmont Lighthouse has been keeping mariners safe on this perilous coast since 1877.

Right: Oakura, a beach village 15 km (9 miles) south of New Plymouth, is its play place. People surf, swim, frolic in the shallows, ride horses, walk dogs and kayak.

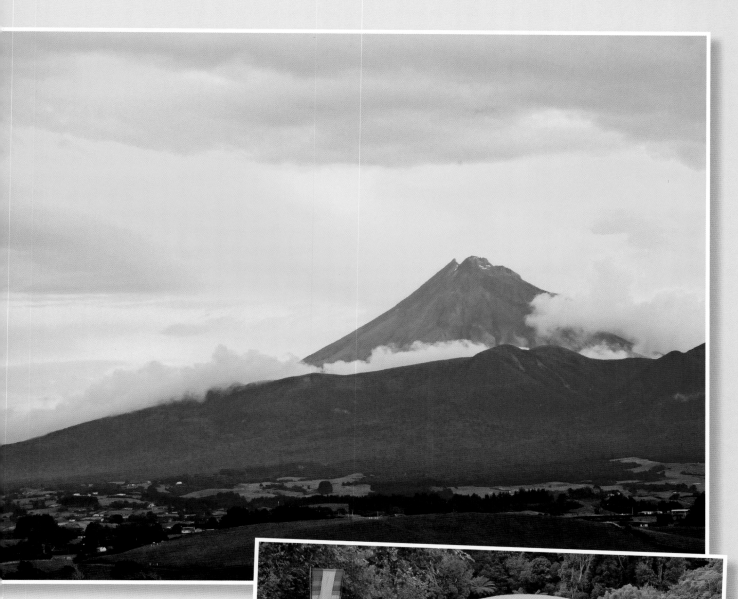

Above: Perfect and much-loved Mt Taranaki is visible from everywhere in the region.

Right: An ancient volcanic crater in central New Plymouth makes a wonderful amphitheatre for outdoor concerts.

Chapter 5: The East Coast

Highway 35, stretching 334 km (208 miles) from Opotiki to Gisborne, curls around the easternmost part of New Zealand. The road has iconic status for Kiwi but is often bypassed by visitors and should not be. It passes many Māori villages as well as remote and exquisite beaches surrounded by steep backcountry farms and forests.

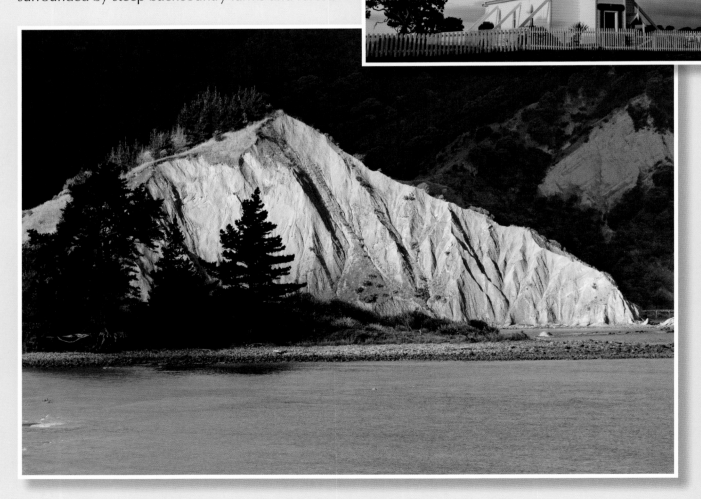

Above: *Tokomaru Bay, one of the first places in the world to be touched by the sun each day.*

Top: *Raukokore Church, 1894, perches on a point next to the sea.*

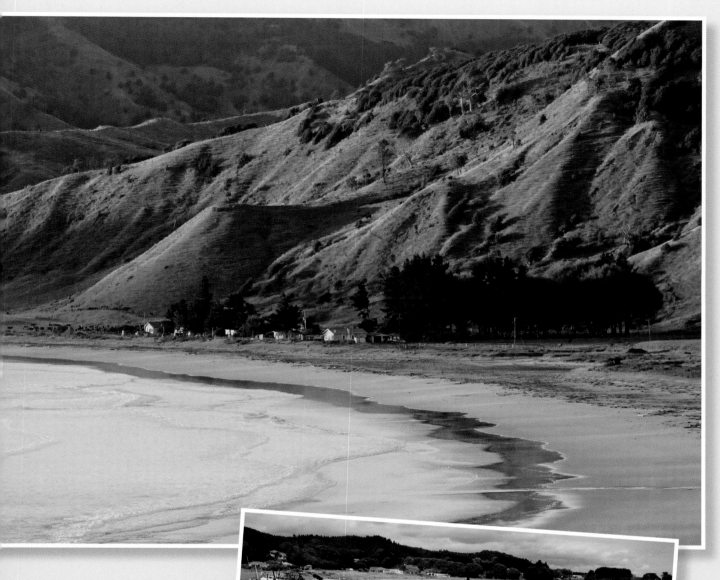

Above: If there is heaven on earth it could be Anaura Bay: fine sand, a clear calm sea, a sweet Māori village, a camping ground and a luxury lodge. It is worth driving the seven-kilometre (four-mile) dirt road to get here.

Right: Gone fishing, Omaio Bay.

Hawke's Bay

Napier, a sophisticated and prosperous little city, is famous for its Art Deco architecture. That is because most of the Victorian buildings were destroyed in an earthquake in 1931 and it was rebuilt when Art Deco was in style.

Below left and right: Every year in February Napier has a week-long Art Deco Festival including concerts and dances, vintage car parades, art exhibitions and Gatsby picnics.

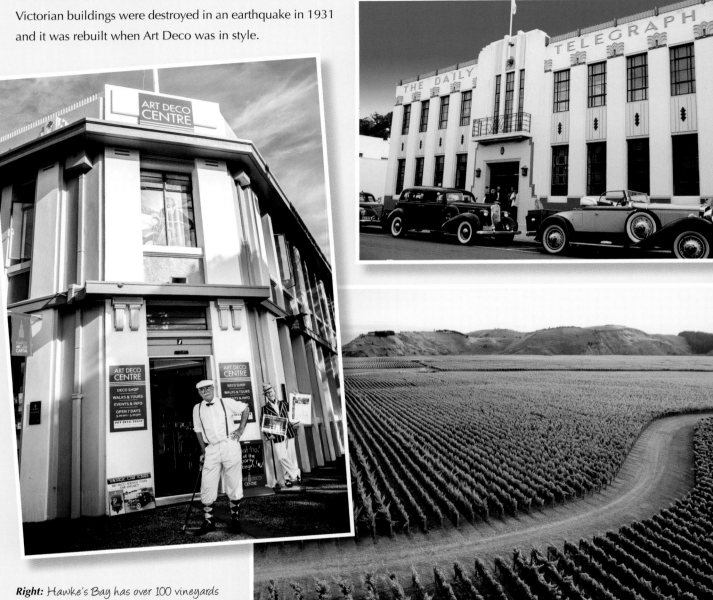

Right: Hawke's Bay has over 100 vineyards and 70 wineries, many with cellar doors and restaurants. By bicycle and on back-lanes is a great way to do a winery tour.

Mount Maunganui

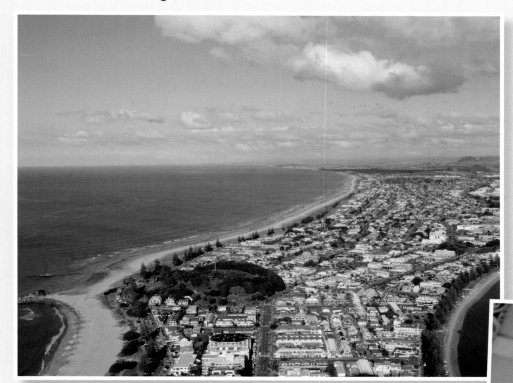

Left: This isthmus is beautifully finished with a conical volcano. Surfers and beach lovers enjoy the east side, and kayakers and sailors the calm west side. All visitors simply must walk around the mountain, if not up it.

Te Urewera

Above and left: Te Urewera, the largest North Island National Park, covers over 2,000 sq km (775 square miles) and is primarily untouched, indigenous forest. It is owned by the Tūhoe people, and jointly managed by them and the Department of Conservation. There are numerous Māori villages within the park.

Chapter 6: Lower North Island

Wairarapa, an hour's drive or train ride over the Rimutaka Range, is Wellington's playground. It has pretty heritage towns, 20 boutique wineries, olive farms and fruit orchards, an annual week-long, hot-air balloon festival, isolated beaches and a ruggedly beautiful south coast.

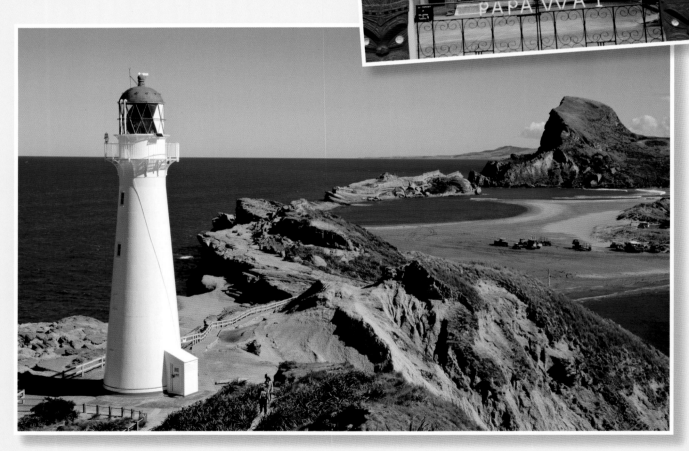

Above: Castle Point Lighthouse, Castle Rock that towers 162 m (532 ft) above the ocean, the reef and the gentle lagoon all make this area great for walking, fishing, swimming and surfing. Castle Point beach horse races, a day of hot sun and thundering hooves, have been held each March for 150 years.

Top right: Papawai Marae, near Greytown.

South Coast

Wairarapa's South Coast is battered by Southern Ocean storms that sometimes cover the road in spume and salt spray, eroding the land. There is majestic scenery where mountains meet the sea, and the hardy people in the little fishing villages would never live anywhere else.

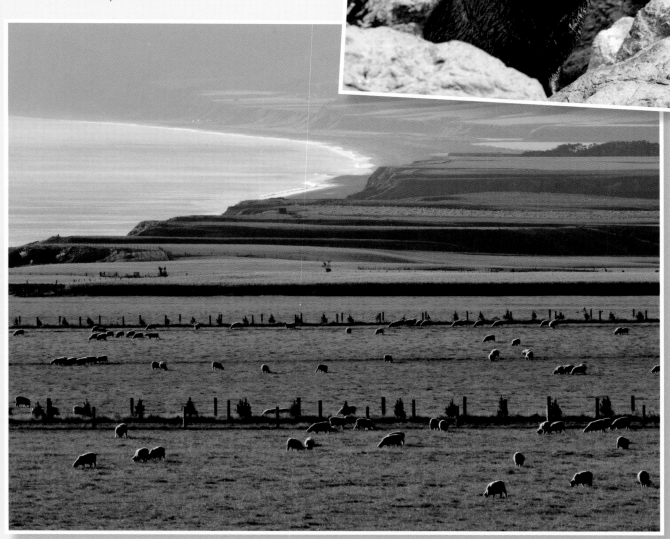

Above: High corn and happy sheep on Palliser Bay farms.

Top right: On the South Coast it's easy to see grown-up seals basking in the sun but the tiny cove where mothers leave their babies when they fish is harder to find. There is nothing as cute as a baby fur seal and, in season, there might be 30 of them playing together.

Wellington

Wellington, the capital city, and seat of government and bureaucracy, clambers between steep wooded hills and a large harbour. The hills make it a pretty city with spectacular views and the squeeze between them means it is compact and walkable. It has excellent universities and is a creative hub for art, design, literature and technology. There are plenty of cafés, bars, theatres and restaurants, all of which contribute to a vibrant scene.

Right: Te Papa Tongarewa, commonly known as Te Papa, is the national museum and art gallery. It is interactive, lots of fun and you can spend a day exploring it. Experience an earthquake, simulated, of course. The gift shop is excellent.

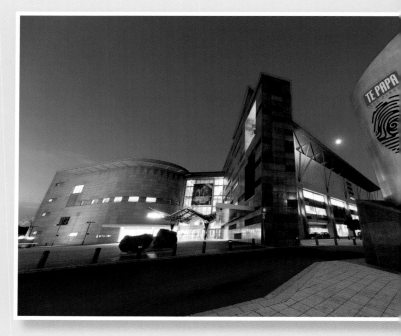

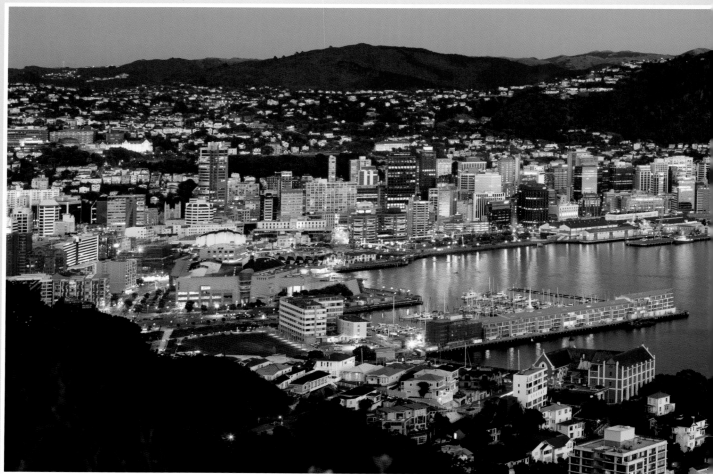

Photos on pages 54-55 © copyright Nick Servian

Right: Oriental Bay, Wellington's own inner-city slice of beach.

Below: The view from the top of Mt Victoria shows this spectacular harbour and city at its best.

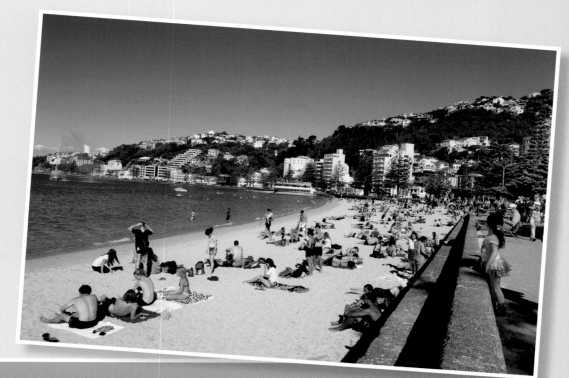

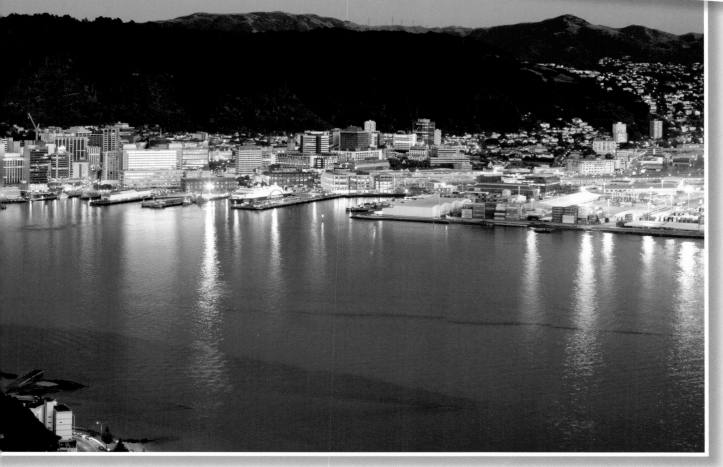

Chapter 7: Marlborough and Nelson

The top of the South Island is known for spectacular coastal scenery and wine. The plains beyond Marlborough Sounds, the flat lands around Blenheim, are dedicated to grapes. From here the world's best sauvignon blanc, and other varietals, is produced. Fine wine is imbibed in good restaurants making this a gourmet's paradise.

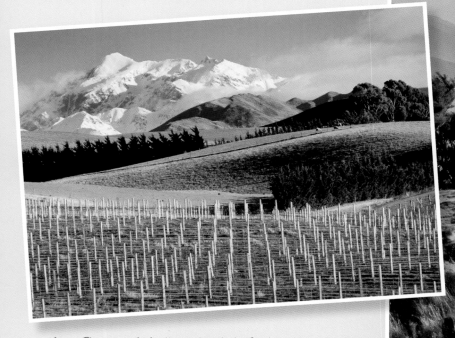

Above: The vines of Marlborough with the Southern Alps behind.

Right: Marlborough Sounds, where land and sea interlock like fingers, comprises thousands of hectares of inlets, islands, quiet coves, and walking and cycling tracks.

Photos on pages 56-57 © Destination Marlborough

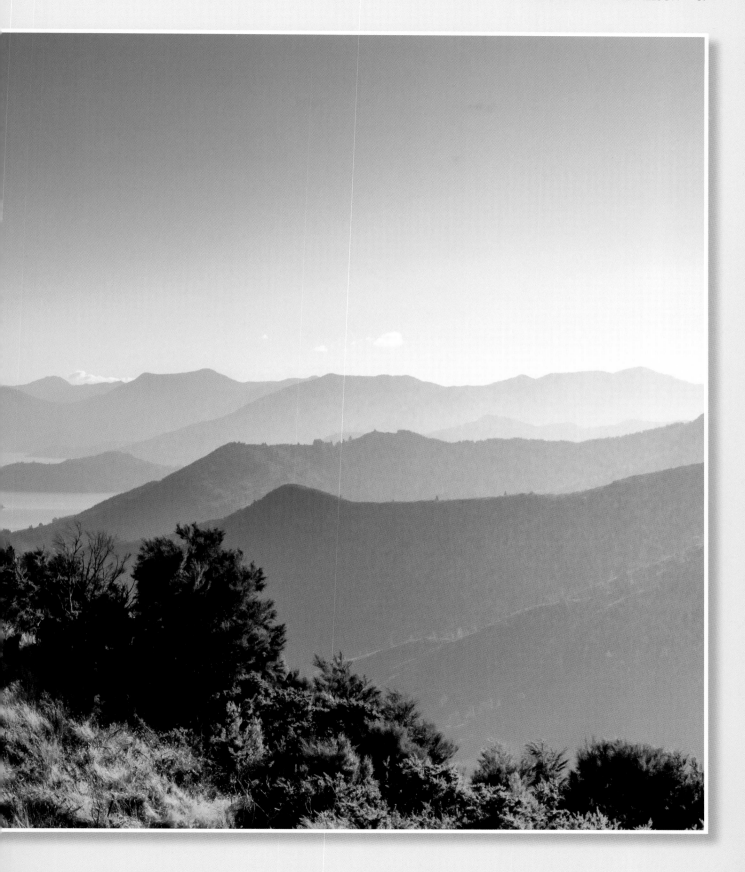

Nelson

Nelson is the sunniest place in New Zealand; orchids abound as do artists, crafts people, winemakers and other boutique food and beverage entrepreneurs. It has a terrific market on Saturdays, selling a myriad of good quality, affordable, locally made products. It is also a boon for outdoor enthusiasts with three magnificent National Parks in the region.

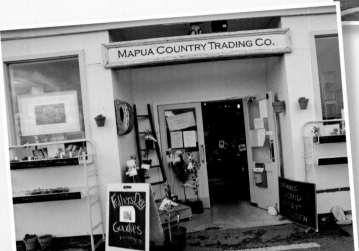

Above: An early settler's cob cottage (made of mud, straw and sand) in the countryside near Nelson.

Left: Mapua Country Trading Company in a sleepy town at the mouth of the Waimea River specialises in local art, crafts and foods.

Below: The 13-km (8-mile) Boulder Bank is an unusual but natural land form that shelters Nelson Harbour.

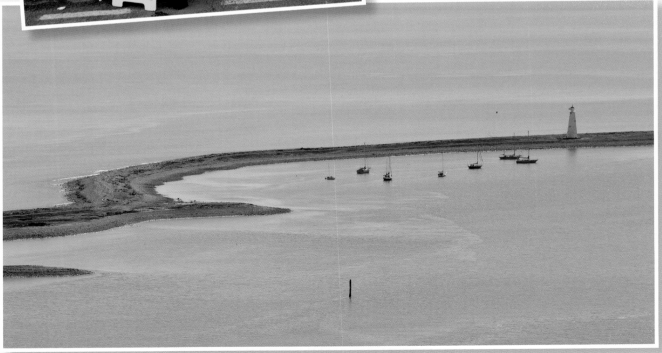

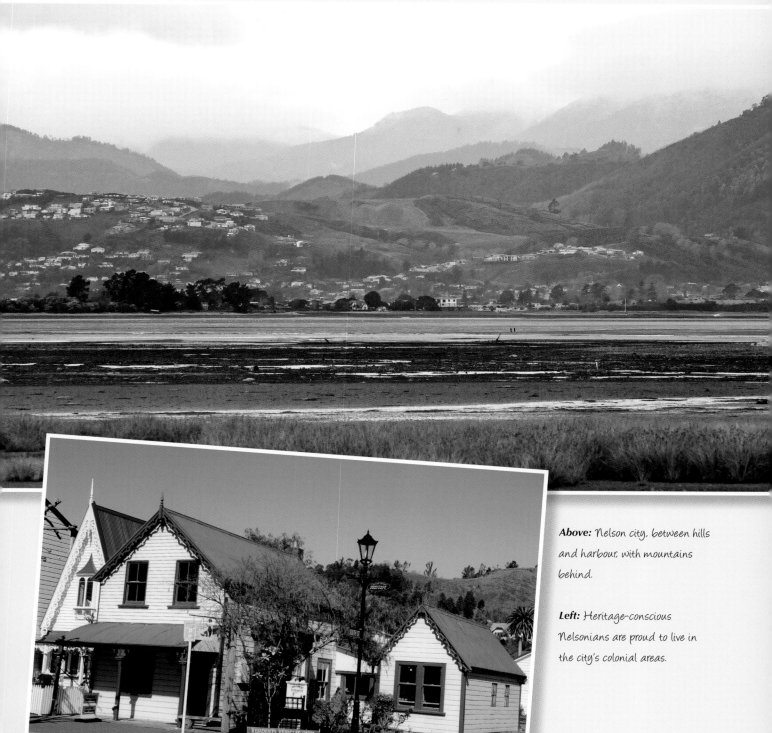

Above: Nelson city, between hills and harbour, with mountains behind.

Left: Heritage-conscious Nelsonians are proud to live in the city's colonial areas.

Chapter 8: The West Coast

Westland, New Zealand's least populated area, is a place of wild weather, big mountains, tempestuous sea and vast rainforest. Thunder roars, wind blows rain sideways then sunshine blasts out from behind retreating black clouds. This is a place for those who enjoy solitude and the beauty of raw nature. Hiking, mountain biking, kayaking, trout fishing and beach-combing opportunities abound. And, of an evening, visitors can cosy-up in bars with big wood fires, in small towns that haven't changed in 100 years.

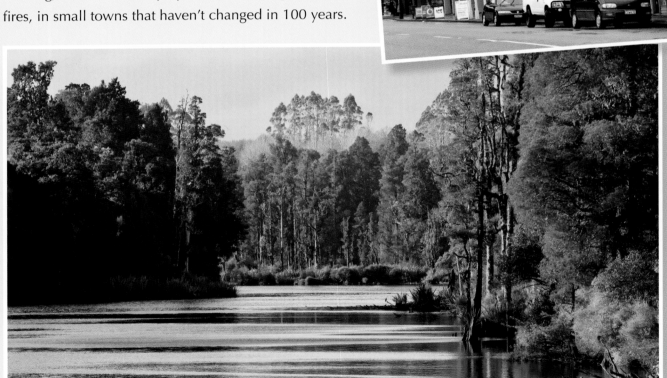

Above: Virgin podocarp forest reflected in the still water of Arnold River.

Top: Reefton, a gold-mining town in a mountain pass, is like stepping into a historic movie but it is real. The buildings are Victorian as are the street lamps. In 1888 Reefton was the first town in the Southern Hemisphere to get public electricity.

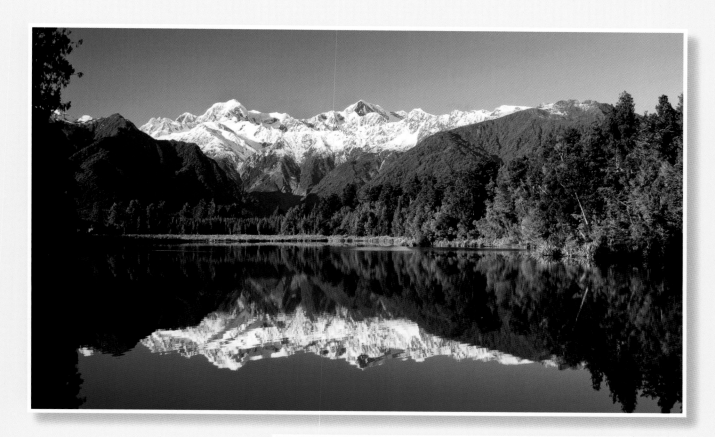

Above: Lake Matheson, in south Westland, is famous for its reflected views of Aoraki/Mt Cook and Mt Tasman.

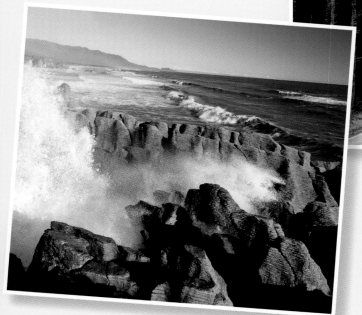

Above: Lewis Pass has thick beech forest in front of spectacular mountain scenery. Visitors are able to see and hear a range of native birds including bellbirds and tūī.

Left: Heavily eroded limestone meets the wild ocean at Punakaiki Pancake Rocks. It is most spectacular at high tide when vertical blow holes explode and roar.

Photo © Garrie Hoddinott

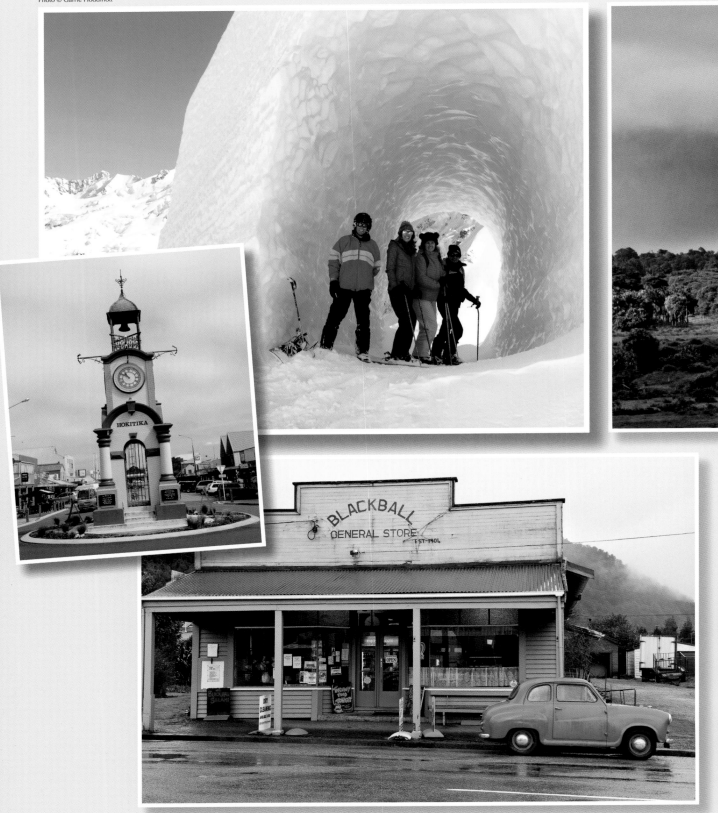

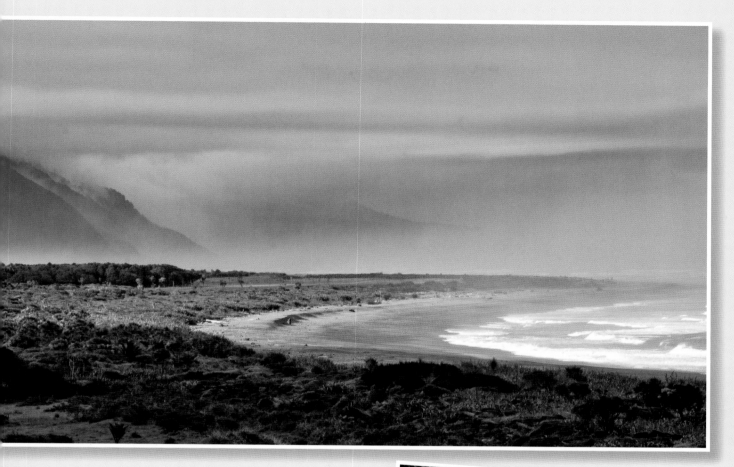

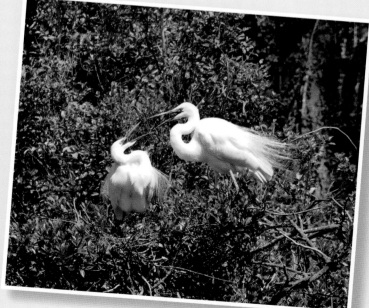

Above: Westland has wild sea, unpredictable weather and a spectacular landscape. Those who live here love it.

Right: The kōtuku is well loved for its brilliant white plumage and large size. It is thought to be a subspecies of the egret family and its sole breeding site is near Okarito Lagoon in Westland.

Opposite top: Franz, Fox and Tasman glaciers provide ample opportunity for climbing and, in this instance, off-piste skiing.

Opposite centre: Hokitika began life as a gold-mining town but has morphed into a travellers' stopping place, and home for artists and adventurers. There are many heritage buildings including the 1903 town clock.

Opposite below: Blackball, once a thriving coal-mining town with 800 people, now has a population of only 40 but it is well worth visiting for its historic ambience.

Chapter 9: Canterbury

In Canterbury, in central South Island, the sea touches the plains then the plains meet the Southern Alps. Hiking, rock climbing, trout fishing and hot-air ballooning are summer activities. In winter the mountains are an alpine paradise with 11 ski fields.

Right: Mt Hutt, 80 km (50 miles) from Christchurch, is the largest ski field in the South Island.

Below: Canterbury's back-country roads offer vistas of lake, pasture land and mountain.

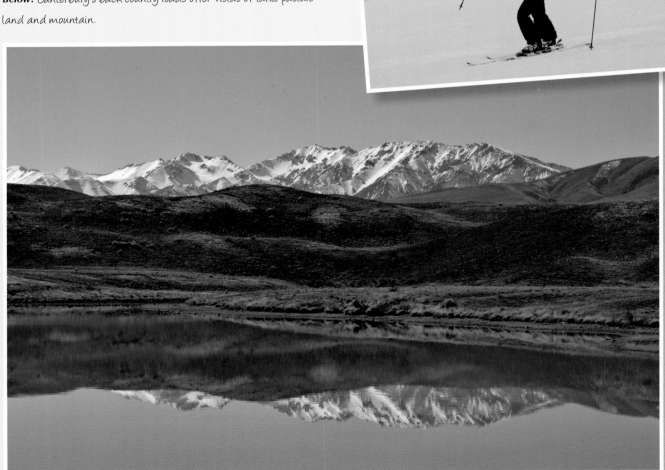

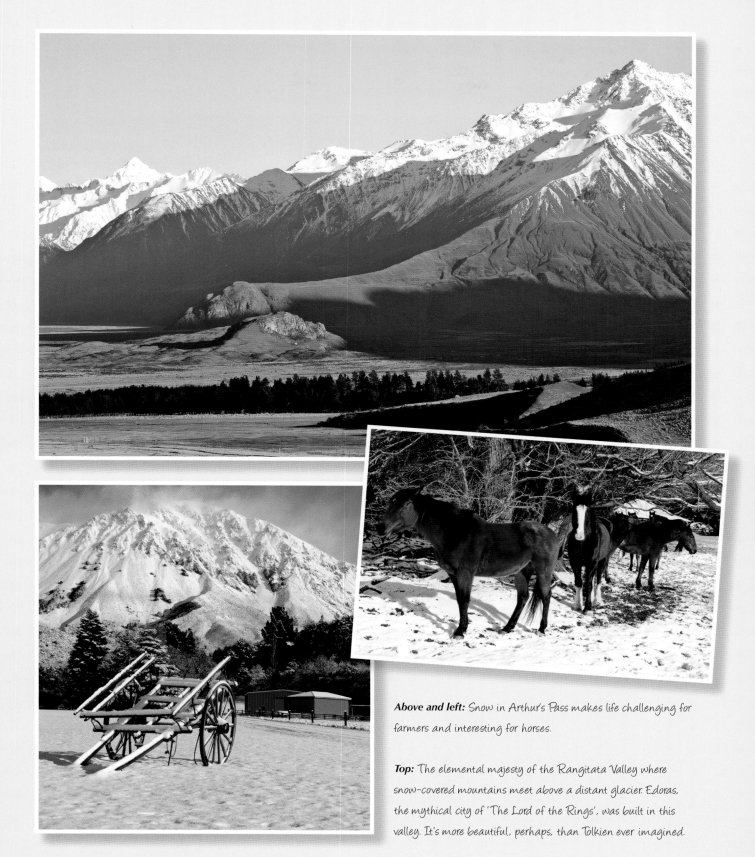

Above and left: Snow in Arthur's Pass makes life challenging for farmers and interesting for horses.

Top: The elemental majesty of the Rangitata Valley where snow-covered mountains meet above a distant glacier. Edoras, the mythical city of 'The Lord of the Rings', was built in this valley. It's more beautiful, perhaps, than Tolkien ever imagined.

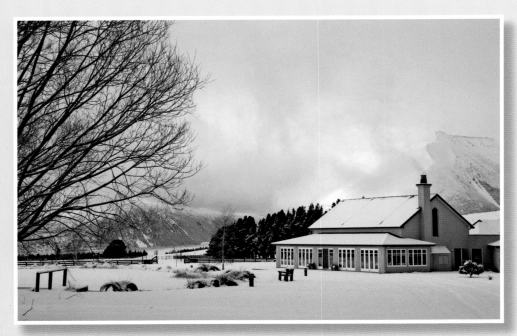

Left: In the uplands snow storms arrive any time between late June and September.

Below: At Mt Potts Station hay is fed to sheep and cattle in the winter months. Cloudy Peak at 2400 m (7,875 ft) stands behind the farm.

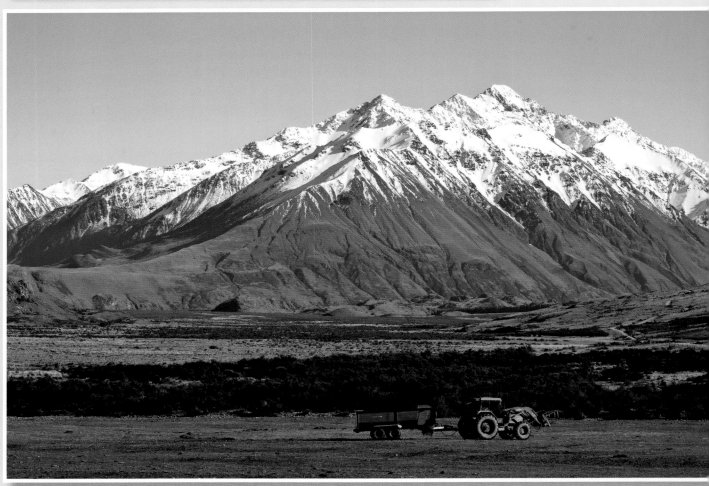

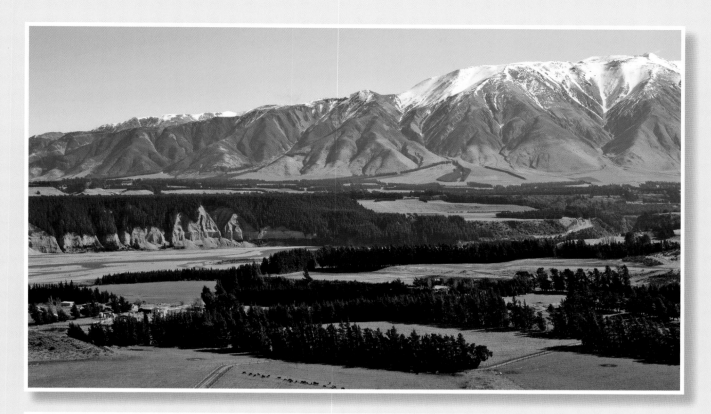

Above: On the plains the Rakaia River is surrounded by lush farmlands and Mt Hutt, nearby, is Christchurch's closest ski area.

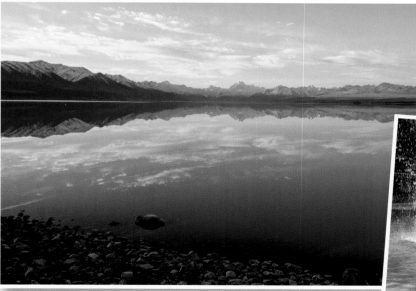

Above: A still dawn at Lake Pukaki with Aoraki/Mt Cook, the highest mountain, in the centre at the far end.

Right: Steaming, thermal, hot-water pools at Hanmer Springs are a treat for all seasons.

Christchurch

In February 2011, on a sunny afternoon, Christchurch, the second biggest city, was rocked by a massive earthquake; 185 people were killed in collapsed buildings and by falling masonry. The city centre was left in tatters and many of the fine Gothic Revival buildings were seriously broken. As were the hearts of all New Zealanders. *Kia kaha*, be strong. And the people of Christchurch were. The rebuild of the city is well underway and many of the cherished heritage buildings have been restored.

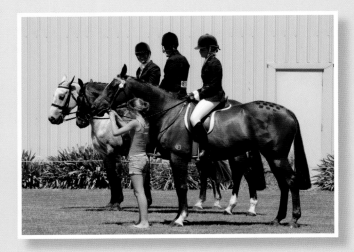

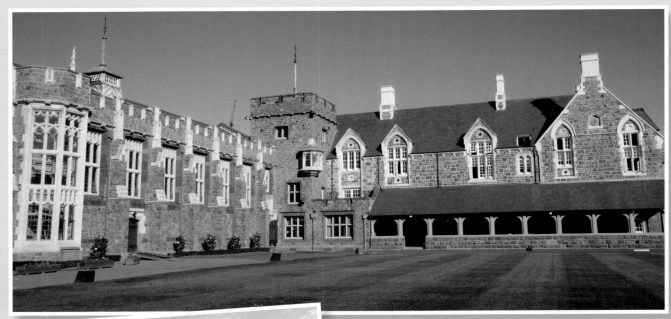

Above: The Gothic Revival architecture of Christ's College remained unscathed by the earthquake as did that of the splendid Canterbury Museum next door.

Left: The earthquake destroyed many buildings and left blank walls on the sides of those that remained. Street and graffiti artists got busy and Christchurch gained a new aesthetic.

Top: The annual Agricultural & Pastoral Show attracts over 100,000 people and 7,000 livestock. It features all sorts of equine, pastoral and horticultural competitions.

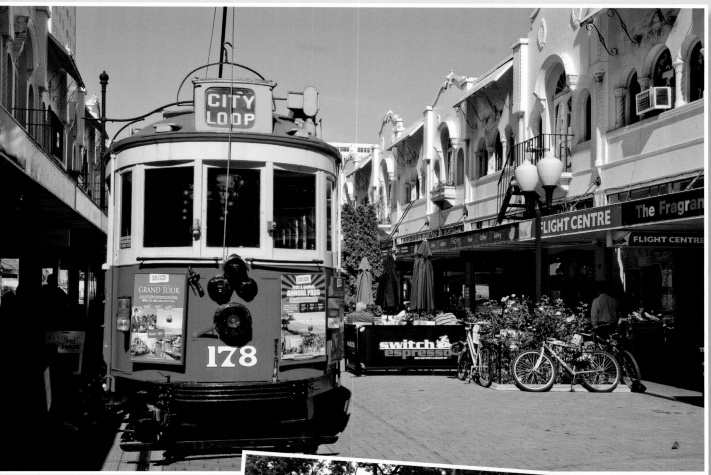

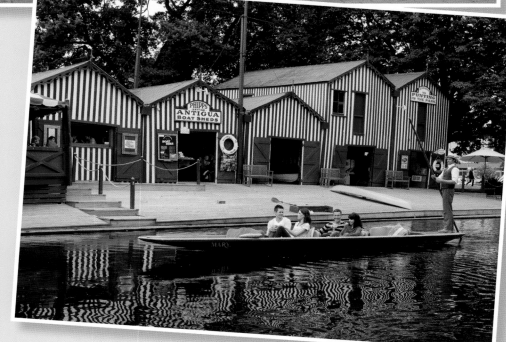

Above: Beautifully restored trams commence their journey around central Christchurch in New Regent Street, a 1930s Spanish Mission-style pedestrian precinct.

Right: Hire a rowing boat or a bike at the Antigua Boat Sheds on the Avon River, or be punted down the river. There is an excellent café here, too.

Chapter 10: Otago

Otago, in the west, has snow-capped mountains, fine lakes and Queenstown, a popular lake-side resort and adventure tourism town. There are also dozens of wineries producing world-acclaimed pinot noir. In eastern Otago, Dunedin is a city proud of its heritage, cultural activities and excellent university.

Dunedin

The first settlers were Scottish; the accent here has a distinctive Scottish burr and a statue of Robert Burns stands in the middle of the city square. Dunedin means Edinburgh in Celtic and like its namesake the city is a vibrant mix of student culture, art and tradition.

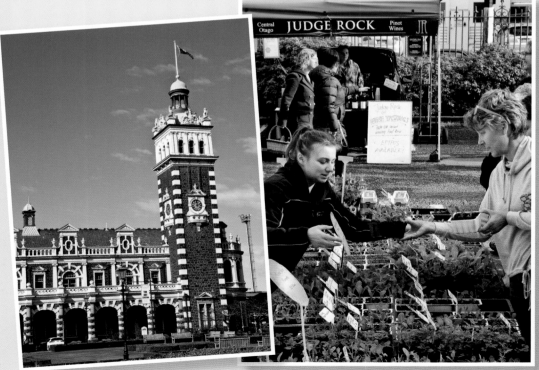

Above: Slow to change and heritage conscious, there are many Victorian buildings in Dunedin.

Left: The Sunday Farmers Market is a well-patronised Dunedin institution.

Far left: Dunedin Railway Station, built in 1906 in Renaissance Revival style, still hosts trains but the building is now also home to the Otago Arts Centre and the NZ Sports Hall of Fame.

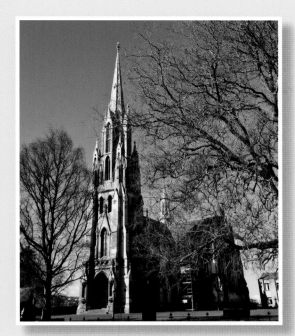

Left: The First Church, completed in 1873, replicates the Norman cathedrals of England but on a smaller scale.

Below: Dunedin has embraced street art with over 30 large commissioned pieces on the exteriors of central city buildings.

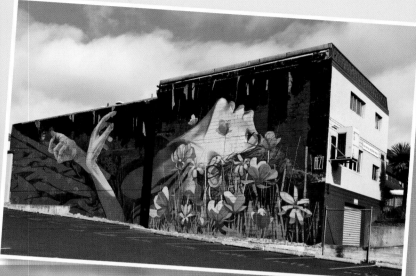

Below: In Port Chalmers, Dunedin's port town, colonial villas bask in the sun on the edge of Otago Harbour.

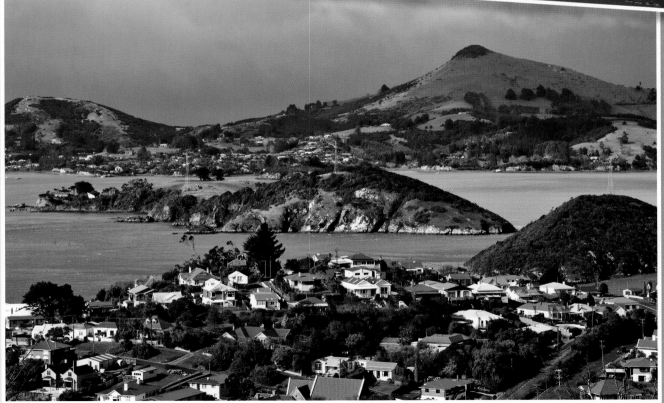

Otago Peninsula

Lucky Dunedin, it has glorious Otago Peninsula on its doorstep. The Peninsula is a steep, hilly finger of land 20 km (12½ miles) long and a few kilometres (miles) wide whose headlands, beaches and sheltered estuaries provide pretty venues for all sorts of outdoor activities. It is also home to penguins, seals and albatrosses.

Top: Gorse flowers gold in spring on the hills around Otago Harbour.

Below right: Farmed hills in the low southern sun.

Below left: Cordyline australis, commonly known as the Cabbage Tree or tī kōuka, is a widely branched monocot tree endemic to New Zealand.

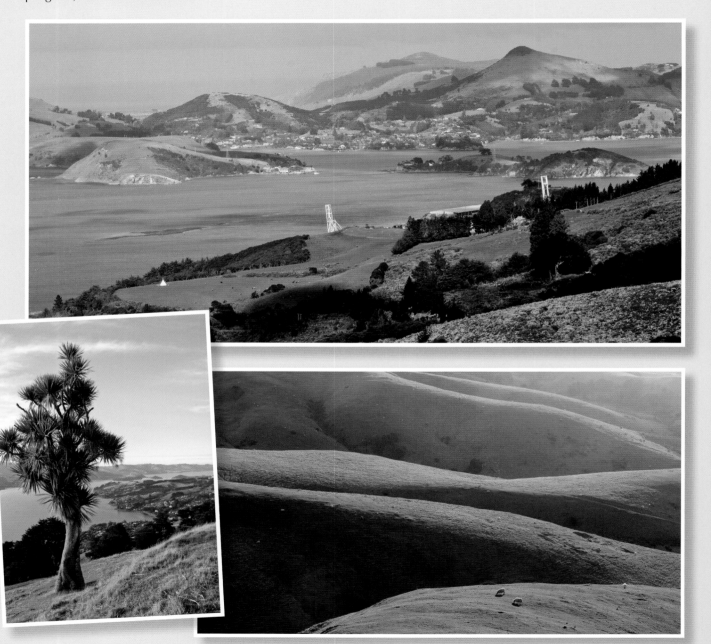

Central Otago

Mountains reach the sky and lakes sparkle. Besides Queenstown, there are many sweet villages in Central Otago. Wineries abound, there are great walks and cycle rides, and, in winter, numerous ski fields to choose from.

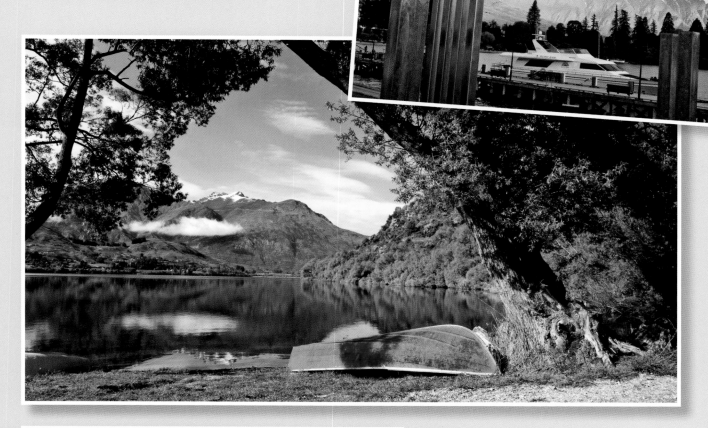

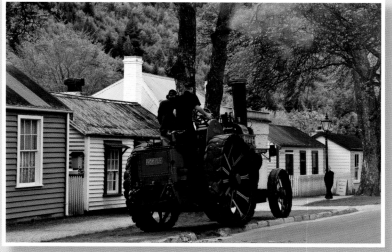

Above: Lake Hayes is circled by a walking path, has great places for picnics and plenty of brown trout for those who enjoy fishing.

Left: In Arrowtown enthusiasts fire up a steam traction engine and take it for a whirl down the main street.

Top: The waterfront at the lakeside resort town of Queenstown with The Remarkables mountains in the background.

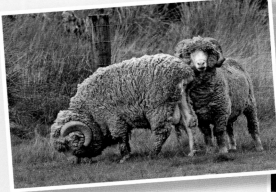

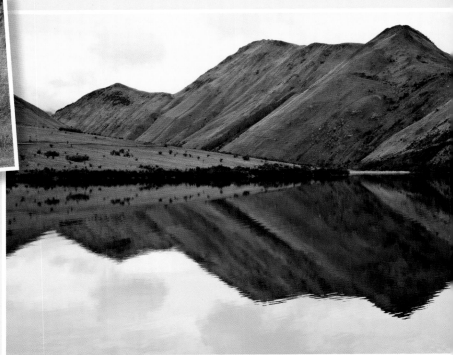

Above left: Merino mountain sheep produce some of the world's finest and longest staple wool.

Above right: Moke Lake.

Below: A rocky perch on the side of The Remarkables is a great place to contemplate Queenstown in the valley far below.

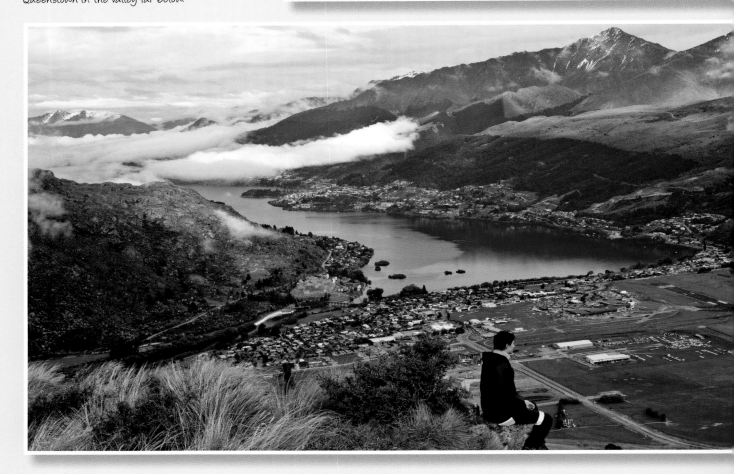

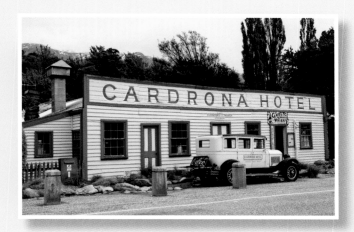

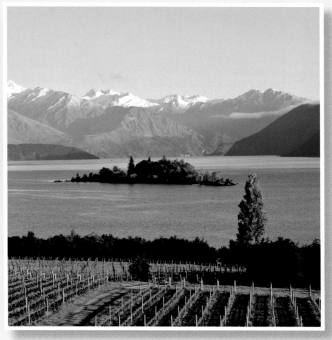

Above: High in the Crown Range, the Cardrona Hotel, built during the gold-rush days, still serves ale and hearty meals to passers-by.

Right: Lake Wanaka and Ruby Island with Twin Peaks in the background.

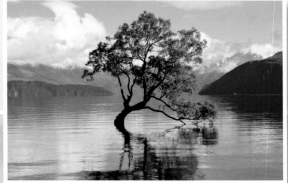

Left: This lonely willow tree thrives in the clear waters of Lake Wanaka.

Below: Lake Wanaka's Glendu Bay with Buchanan Peaks in the background.

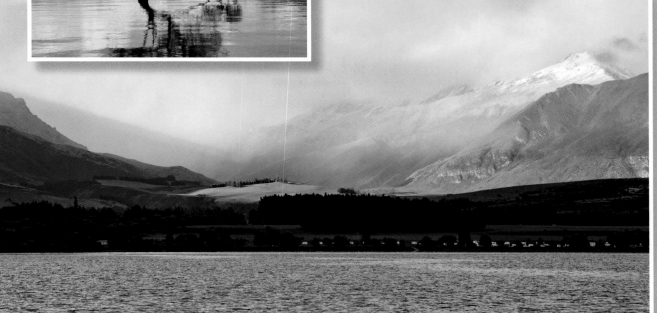

Getting About

Cars, motorhomes, campervans, buses, trains, ferries and bicycles are all modes of transport for visitors to New Zealand.

It's a long country and has a low population so, it is fair to say, the roads aren't up to the standard of Europe or the U.K. Many of the remoter roads are small, winding and surfaced with gravel; the sealed roads can be small and winding, too, but remote roads have few cars. There are motorways to and from Auckland, Wellington and Christchurch otherwise most of the national highways are only two lanes with clearly designated passing areas.

Visitors often hire a car, motorhome or campervan at Auckland, Christchurch or Queenstown airports and tour the country by road. Driving is on the left-hand side of the road and visitors who are used to right-hand drive need to take particular care of this. Every year tourists kill themselves and people in oncoming vehicles by driving on the wrong side of the road.

KiwiRail Scenic Journeys offers three different train journeys that can be connected giving train enthusiasts an extensive coverage of New Zealand's spectacular scenery in comfort. Also, you can stop off in Auckland, Wellington, Picton, Christchurch and Greymouth. The *Northern Explorer* traverses the main trunk line between Auckland and Wellington across the interior of the North Island and the *TranzAlpine* crosses the South Island from coast to coast. The *Coastal Pacific* that journeyed between Christchurch and Picton was taken out by an earthquake in 2016 but should be operational again by 2018.

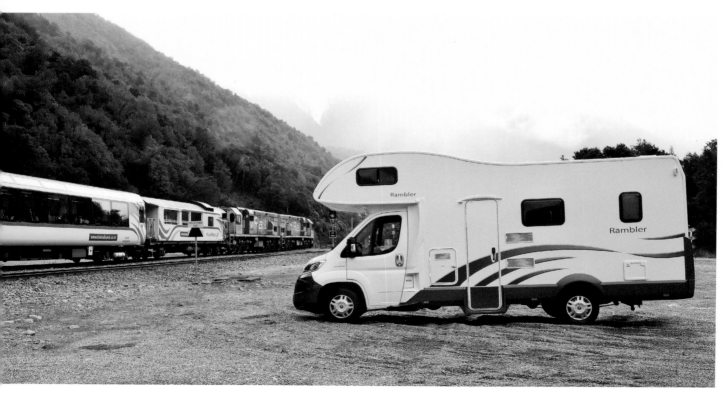

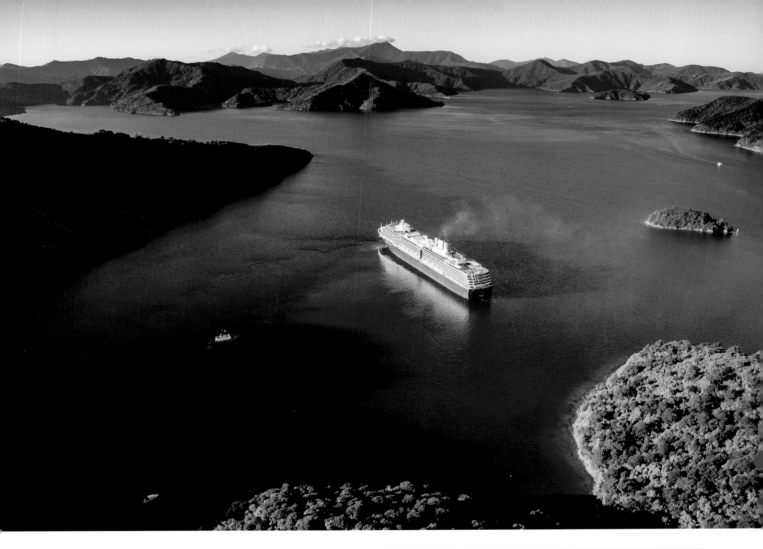

The Kiwi Experience, a fleet of buses that travel most routes in a hop-on and hop-off mode with clients using pre-purchased tickets of different durations, is primarily aimed at backpackers. There are also bus touring companies, often aimed at a more affluent and older age group, which take people on various pre-scheduled tours of the country.

Auckland has an integrated train, bus and ferry service which links through on one ticket. Wellington has an excellent suburban train and bus network.

Air New Zealand is the national airline but there are numerous other small route-specific carriers. JetConnect is a low-cost airline operating between the main centres.

Cycle touring is becoming more popular with many off-road bicycle trails. There are modes of touring and transport to suit all tastes, fitness levels and pockets.

Above: Campervans are a budget way to travel around.

Top: Numerous cruise ships sail around New Zealand.

Resources

CONTACTS

www.tourismnewzealand.com
This website includes all the 29 regions.
www.airnewzealand.co.nz
Air New Zealand for international and domestic flights.
www.kiwirailscenic.co.nz
KiwiRail for train journeys and the inter-island ferry.

REFERENCES

Books

Bowden, D. (2017). *Great Railway Journeys in Australia and New Zealand.* John Beaufoy Publishing Ltd.
Dawson, J. & Lucas, R. (2011). *New Zealand Native Trees.* Craig Potton Publishing
Heather, B. & Robertson, H. (2015). *The Field Guide to the Birds of New Zealand.* Penguin Random House New Zealand Ltd.
Jansen, P. & Fear, A. (2009). *Touring the Natural Wonders of New Zealand.* New Holland Publishers (NZ) Ltd

Films

Hunt for the Wilderpeople (2016)
The Hobbit Trilogy (2012, 2013, 2014)
Boy (2010)
Whale Rider (2003)
The Lord of the Rings Trilogy (2001, 2002, 2003)
The Piano (1993)

ACKNOWLEDGEMENTS

Thank you to Nick Servian, Garrie Hoddinott, Hawke's Bay Tourism, Destination Marlborough, Christchurch & Canterbury Tourism and West Coast Tourism for providing supplementary photographs. And special thanks to Sam Tracy, who loves driving, and joins the author on her photographic adventures in New Zealand.

ABOUT THE AUTHOR

Liz Light is an Auckland-based travel writer and photographer. She travels extensively but it is New Zealand, her homeland, that holds her heart. She utterly loves its splendid scenery, and its open, new-world attitudes and ambience. Liz has won numerous awards for both her writing and photography.

Index

DISCARD

.ed in the United Kingdom in 2017 by John Beaufoy Publishing,
11 Blenheim Court, 316 Woodstock Road, Oxford OX2 7NS, England
www.johnbeaufoy.com

ISBN 978-1-909612-93-8

Designed by Glyn Bridgewater
Cartography by William Smuts
Project management by Rosemary Wilkinson

Printed and bound in Malaysia by Times Offset (M) Sdn. Bhd.

All photos by Liz Light except for: Christchurch & Canterbury Tourism (p65 bottom); Destination Marlborough (p56, p57);
Garrie Hoddinott (p63 centre, p74 top right); Hawke's Bay Tourism (p50); Hobbiton Movie Set (p28); Nick Servian (p54,
p55); Tourism West Coast (p73 top and bottom).

Cover photos © Liz Light

Front cover (top, left to right): *A Māori girl in traditional costume*; *A restored vintage tram, Christchurch*; *The First Church
in Dunedin*, *The tūī, endemic to New Zealand*. Front cover (centre): *Lake Taupō, North Island*. Front cover (bottom): *Lake
Wanaka and the Rippon Vineyard*. Back cover (left to right): *A Māori church in Northland*; *The rolling green hills of the
Otago Peninsula*; *Sculpture from the collection at Gibbs Farm*; *Surfers on Te Ārai Beach in Northland*.